Global Graphics: Symbols

ROCKPORT

Global Graphics: **Symbols**

Designing with Symbols for an International Market

Anistatia R Miller & Jared M. Brown

·

Cheryl Dangel Cullen

GLOUCESTER MASSACHUSETTS

ROCKPORT PUBLISHERS

First published in the
United States of America by:

Rockport Publishers, Inc.
33 Commercial Street
Gloucester, Massachusetts 01930-5089

Telephone: (978) 282-9590
Facsimile: (978) 283-2742

www.rockpub.com

ISBN 1-56496-512-0

10 9 8 7 6 5 4 3 2 1

Designer: Stoltze Design
Layout and Production: Cathy Kelley Graphic Design

Cover Image: Stoltze Design

Printed in China.

Contents

Introduction

by Maggie Macnab

Macnab Design Visual Communication
http://www.macnabdesign.com

We are surrounded by billions of natural forms, all based on a few simple patterns. Branchings, spirals, 120-degree angles, and meanders form some of the complex codes by which clay cracks or bubbles separate, organisms grow pre-programmed by genetic imprint and mutate by circumstance, or rivers unwind in asymmetrical harmony.

Like nature, we also exist by pattern. We observe our surroundings; our hands create what our eyes perceive and our minds envision. Because our experience of life is both one of inquiry and definitive finality, it is fundamental to our nature to devise ways that tangibly demonstrate the theoretical. Symbols become our palpable metaphors.

Social living is filtered through the mutable filigree of human communication. As the ancestor to written language, symbolic images are the foundation for written communication and have evolved from the most minimalist beginnings into complex abstractions. As intrinsically necessary as the patterns underlying nature, the most ancient symbols are a conduit to the present. A circle can represent everything (all encompassing) and nothing (zero); a square can represent earth, stone, and solid foundation; a triangle can signify the relationship of the material to the unseen; a spiral can symbolize return, time, or evolution.

Despite our subconscious recognition of many archetypes, not all are universal in their interpretation. Emerging out of different times and places in human history and sometimes branching in opposite directions, similar images can mean very different things. For instance the owl in most western cultures represents "all-seeing" wisdom, while to a Navajo it is a sacred image of foreboding and death. Other symbolic meanings are forever altered out of human events so powerful in emotional memory they can edit history: the ancient version of the clockwise swastika developed in Sumeria over 5,000 years ago will never again be initially associated with its original meanings of positive power, energy, and migration.

Symbols echo our subjective interpretations of the world around and within us: some are precise in their significance, such as modern-day directional signage. And some access a level of intuitive knowledge: a sort of collective shorthand of human design that all comprehend, from Cro-Magnon to modern day humans. As our creations, symbols are both internal and external mappings of the human landscape, and like the image of the circle, remind us that at our essence we are all connected to each other and all things throughout time.

How to Use This Book

The accompanying examples of commercial symbols represent successful application of traditional symbology in a variety of packaging, advertising, direct mail, collateral, identity, web, broadcast, and other design projects. Examples of symbols are grouped geographically by continent, by region, and by nation, presenting the use of familiar and unique symbols that best portray each area. An overview of each location outlines general ideology and history. Within each section, traditional symbols are grouped into five categories: animal, plant, person, shape, and gesture. Under these banners, you'll find concise outlines of the symbols that are commonly associated with each region or nation.

There are also some valuable tips from designers and companies who have crossed cultural borders by designing projects for broad global markets or have expanded their own cultural vocabulary by designing for specific foreign audiences. These thoughts have been interjected throughout the text on how to incorporate traditional cultural symbols into design projects that need to communicate to or identify with a specific culture.

In every culture, mass communication depends to a great extent on signs and symbols. In fact, the written word itself is nothing but a series of recognizable visual signs employed to convey a message. Designers and product developers create logos and trademarked names that become signs of the object or idea each is meant to represent, acquiring an identity through regular usage and public acceptance.

Designers are visual ambassadors, creating vehicles of communication intended to carry messages within or across cultural barriers. Communication, however, is by nature subjective: an individual's perceptions are influenced by the segment of the world one is exposed to; these perceptions in turn color the individual's communication. It's for this reason that designers unintentionally incorporate symbols representative of their native or adoptive cultures into their design solutions. And sending the message is only half of communication. People viewing visual symbols also interpret them subjectively, based on their own set of personal and cultural understandings. Unlike signs, symbols have deeper meaning. Each word or picture implies an emotion or thought in addition to its obvious and immediate significance when placed before a particular audience.

This volume of *Global Graphics* is intended to help you understand what traditional symbols mean in various parts of the world so that you can intentionally apply or avoid them in your own design solutions.

North America

The North American continent is a cultural and symbolic hybrid, occupied by young nations whose inhabitants have imported their traditions and taboos from the world over.

One thing they have all have in common is that North Americans love and respect nature and the wilderness. This sentiment has spawned some high-profile symbols that have become recognized throughout the world. The American cowboy, Canadian maple leaf, the Royal Canadian Mounted Police, the American bald eagle, and the grizzly bear are just a few of the elements to be found in the vast North American visual vocabulary.

Cultural metaphors with a tropical flavor can be found on the Caribbean islands that stretch from the coast of the southeastern United States down to the tip of South America. Pirates, parrots, and white sandy beaches present another facet of the North American persona. And the unique blending of Spanish Catholic tradition with Aztec and Mayan iconography found in Mexico. Desert cactus, Aztec idols, and historic figures such as Montezuma II provide yet another layer of visual symbolism and texture to the list of North American icons.

United States

A myriad of cultures and subcultures, each with its own symbols and shared imagery, make for a rich history of emblems and icons.

The thirteen red and white stripes in the U.S. flag symbolize the original colonies, while the fifty stars depict the states admitted into the union.

The United States is a young country. Its initial burst into world history—the American Revolution—coincided with the early stages of another revolution, the Industrial one; and for most of the past two centuries its destiny was intimately tied to the course of industrial development. Images of industry—from products to working people at work or play—mix with images of vast spaces and untamed natural splendor to form an overall conception of a promising land brimming with resources and vitality.

Though it's commonly referred to as a melting pot of cultures (and despite the fact that satellite communications beaming American culture and iconography around the world have tended to homogenize and Americanize entire generations globally), the U.S. really contains a myriad of cultures and subcultures, each with its own symbols and shared imagery, which may or may not carry the same meanings. Different peoples settled in different areas—Acadian French in Louisiana; Spanish in southern California; English, Irish, and Scottish in New England—and as result regional differences abound.

Still more differences can be attributed to the huge variations in climate and physical environments: from the seemingly endless southern summers, to the bountiful heartland harvests, the historic eastern seaboard, and the still rather untamed mountains along the Continental Divide. These varied symbolic textures provide great opportunities for designers who pay attention to them, and great stumbling blocks for designers who don't.

Animals

The bald eagle is the national emblem. The donkey and the elephant symbolize the nation's two presiding political parties: the Democrats and the Republicans, respectively. But there are other American animal metaphors. For example, the California grizzly bear has been that state's symbol since its adoption in 1953. American children are naturally fond of bear images such as Winnie the Pooh (named after a Canadian regimental mascot from Winnipeg, donated to the London Zoo during World War I) and the Teddy bear (named after President Theodore Roosevelt, who at one point had a pet grizzly bear cub, which he had refused to shoot on a hunt because it had been tethered to make it an easy target). The bear, however, is also a symbol of depressed stock market prices, a reference supposedly originating from the adage "to sell the bear's skin before one has caught the bear."

✦ *Plants*

Even though the United States is not the world's only producer of corn and wheat, these two plant symbols are often used in American design to convey the concepts of abundance, harvest, and food. Wheat has long been dubbed the staff of life.

✶ *People*

With such a diverse ethnic population and multifaceted culture, no single character epitomizes the American spirit in the way that Sherlock Holmes and Queen Elizabeth II represent the British. However, there are a number of very American characters, from classic figures such as Uncle Sam and G.I. Joe to pop-culture icons such as Marilyn Monroe, John Wayne, and even Mickey Mouse.

▢ *Shapes*

The light bulb has been typically used by Americans to symbolize a bright idea. The simple shape has often appeared above the heads of comic strip or cartoon characters who have just found a solution to a problem.

⇨ *Language/Gestures*

The thumbs-up gesture is an American symbol for approval, especially when accompanied by an all-knowing wink of the eye and a smile. But this visual display meant life in ancient Rome. When the gladiators fought in coliseum events, the final outcome of a duel to the death was decided by the spectators and the emperor. A thumbs up indicated to the winning gladiator that his opponent should be allowed to live; a thumbs down mandated a sentence of death for the loser.

Mountains

Universal Symbol
BECAUSE IT WAS THERE

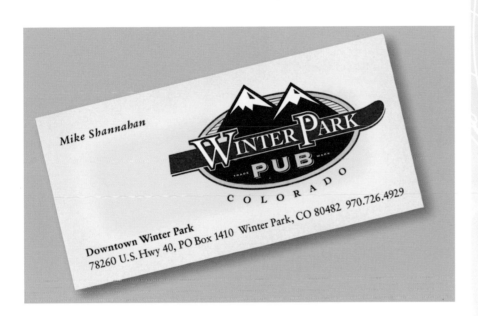

Many cultures—including the ancient Greeks, Romans, and Native Americans—have regarded mountaintops as the home of gods and symbolic of heaven. In the United States, the Rockies, the Sierra Nevada, the Grand Tetons, the Cascades, and other mountain ranges symbolize the strength, grandeur, and beauty of the American wilderness; in another context, they have come to symbolize the ambition of scaling the highest peak of success. For example, Paramount Pictures features a mountain encircled by stars. Shasta, a soft drink manufacturer, uses a silhouetted image of California's Mt. Shasta in its visual identity. Peak Performance energy bars use the obvious double meaning in both their name and visual materials.This symbol is similarly comprehended and applied around the world. Mt. Fuji symbolizes the country of Japan and also implies, in Japanese culture, that something or someone has reached the highest peak of achievement. The Matterhorn, Mont Blanc, Kilimanjaro, K-2, and Everest have similar connotations in their respective countries and around the world. Used alone or in combination with stars, the sun, the moon, or other elements, a mountain can communicate success to a broad, international audience.

Portraying both its location and its success in the marketplace by the use of a mountain as its central design element, this logo for a pub located in the Rocky Mountains was designed by Neil Becker, Becker Design.

PROJECT	**WINTER PARK PUB LOGO**
DESIGN FIRM	**BECKER DESIGN**
DESIGNER	**NEIL BECKER**
CLIENT	**WINTER PARK PUB**

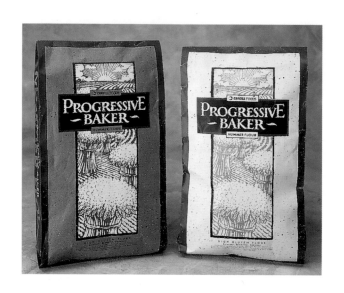

Wheat is often referred to as the staff of life. And it is also the main ingredient of products sold by the Progressive Baker. Carmichael Lynch used shafts of wheat—an icon of an abundant harvest—to convey a strong message on these packages.

PROJECT PROGRESSIVE BAKER PACKAGING
DESIGN FIRM CARMICHAEL LYNCH
ART DIRECTOR/
DESIGNER PETE WINECKE
CLIENT CARGILL

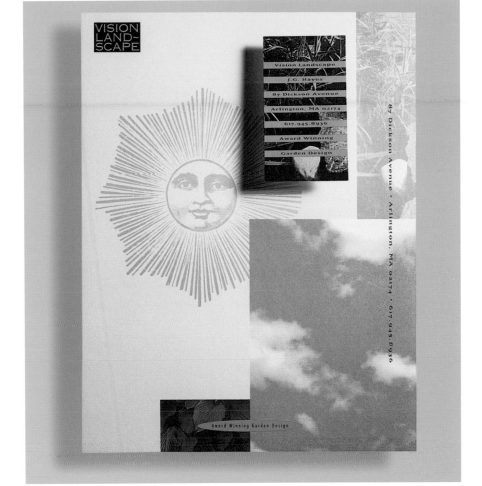

Using the sun as a metaphor for enlightenment and leadership, Gary Ragaglia created this letterhead for The Vision Group.

PROJECT — **THE VISION GROUP**
DESIGNER — **GARY RAGAGLIA**
CLIENT — **VISION LANDSCAPE COMPANY**

Global Graphics: Symbols

The Eagle

Ancient Greeks believed that the eagle symbolized royalty, power, authority, and victory. In Assyria, the eagle stood for volatile events such as storms and lightning as well as fertility. In Assyrian art, the deity who carried human souls to the afterlife took the form of an eagle.

The double-headed eagle was a symbol of the Austro-Hungarian empire, Serbia, and Czarist Russia prior to World War I, and it is still incorporated into the national insignia of Albania. When crowned and bearing a sword in its claws, it becomes the supreme symbol of the Scottish Rite, signifying the thirty-third degree of Scottish Rite freemasonry. In this instance it represents the transcendent perfection that arises from the fullest revelation of an individual's potential. This very same image was worshipped by the Hittites as a symbol of omniscience. A simple double-headed eagle motif, with the body in profile, also appeared as early as the fifth century in Pakistan.

Christian artists associated the eagle with the evangelist Saint John, symbolizing his perceptive and contemplative nature. And the United States' national bird—the bald eagle—represents intellect and power. But it is the Aztecs who devised a truly striking symbology around this raptor. The eagle—quanhtli—is the fifteenth of the twenty astrological signs of the Aztec calendar, representing fertility and military strength. Aztec warriors were divided into two elite fraternities: eagles, the empire's largest raptors; and jaguars, the empire's largest land predators. Together these two factions symbolized the polarity of the sun and the stars, which were the ultimate powers of the heavens.

The Aztec goddess Quauh-Cihuatl's crown of eagle feathers marked her leadership of all women who had heroically died in childbirth—a deed considered as important as capturing a prisoner in battle. An eagle pictured on a rock signified a warrior ready for hand-to-hand combat. Portrayed in combat with a snake, the eagle was the symbol of the Aztec capital Tenochtitlan (Mexico City). This powerful image, which is the national seal of Mexico, also represents the eternal contest between the sun and the clouds for rulership of the skies. However, the Hindus of India consider this same pairing to be a portrayal of Garuda, who transported the god Vishnu through the heavens.

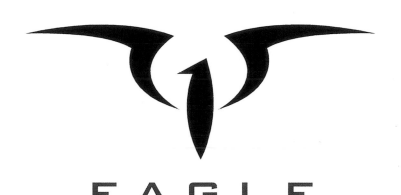

E A G L E
S P E A K E R S

The eagle employed by Gillis + Smiler for this speaker company conveys power and authority—natural metaphors for this bird

PROJECT EAGLE SPEAKERS LOGO
DESIGN FIRM GILLIS + SMILER

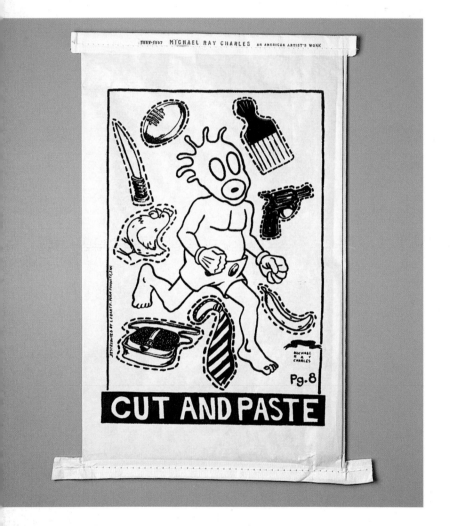

 Artist Michael Ray Charles' work is collectively featured in this commemorative package from Rigsby Design that explores the history of racist, black stereotypes and pop-culture black symbology. A handbook traces a century's worth of history as stereotypical black icons that appeared in popular advertising featuring such familiar American characters as Uncle Ben, the Gold Dust Twins, and perhaps the most recognized black stereotype of all, Aunt Jemima. A running commentary by black historian Marilyn Kern-Foxworth and filmmaker Spike Lee accompanies the pictorial retrospective and provides insight to the cultural impact of these symbols.

Rather than deny that these stereotypes exist, Michael Ray Charles' provocative illustrations recast these icons in a positive light. Many of his illustrations are featured in an accompanying poster-size exhibition catalog that features Aunt Jemima as a presidential candidate and as a "mammy" figure against the traditional Norman Rockwell *Saturday Evening Post* backdrop.

"Central to the artist's work is the idea that stereotypes force participation in the creation of meaning. We don't want to know what 'those words/images' mean, but we do," said Lana Rigsby. "This thesis is presented as a puzzle; interlocking black and white pieces (some missing) that don't quite complete the story.

"Our design challenges viewers to acknowledge their role as active participants in perpetuating stereotypes—there's no way to passively view the piece," explained Rigsby, citing that the hand-sewn bag must be cut open to access the books inside and that a black Mickey Mouse (another American icon) on the bag's face encourages viewers to cut and paste his clothing, much like one would play with a paper doll.

While the entire package incorporates a multitude of symbols, there is one hidden symbol—that of a hand-glued penny—that is the artist's signature. The U.S. penny features the image of Abraham Lincoln—The Great Emancipator—facing the opposite direction of all other presidential profiles featured on U.S. coins.

PROJECT MICHAEL RAY COMMEMORATIVE
 PACKAGE/EXHIBITION CATALOG
DESIGN FIRM RIGSBY DESIGN
ART DIRECTOR LANA RIGSBY
DESIGNERS LANA RIGSBY, AMY WOLPERT
ILLUSTRATOR MICHAEL RAY CHARLES
PHOTOGRAPHERS PATRICK DEMARCHELIER, SHARON SELIGMAN
COPYWRITERS SPIKE LEE, MARILYN KERN-FOXWORTH
EDITOR LANA RIGSBY
CLIENT BLAFFER GALLERY (UNIVERSITY OF HOUSTON),
 MICHAEL RAY CHARLES

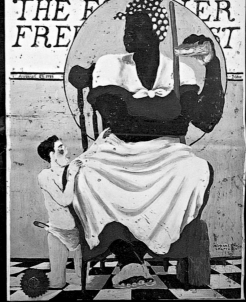

THE MANY PURPOSE CLEANER

FAIRBANKS

GOLD DUST

WASHING POWDER

PAINTING POSITIVE PICTURES OF IMAGES THAT INJURE
MICHAEL RAY CHARLES' GUILING QUALITIES

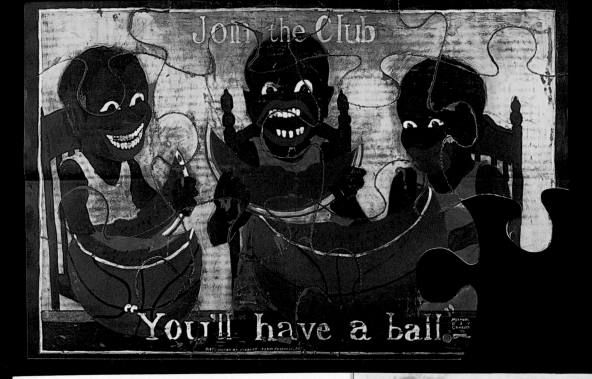

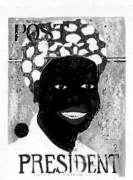

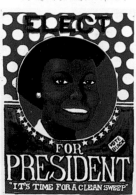

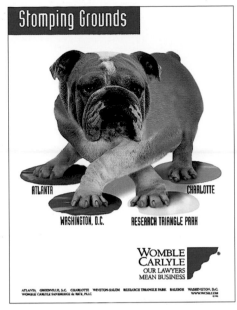

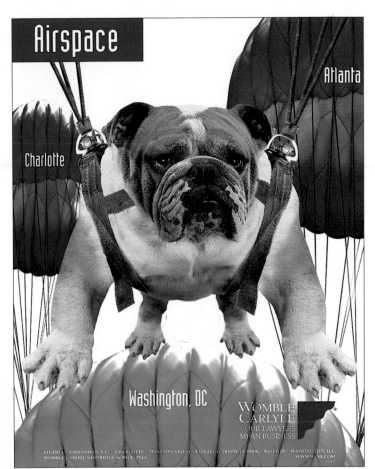

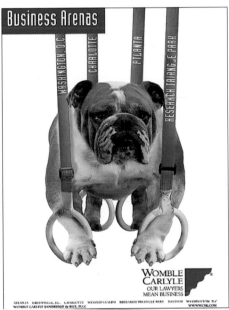

In this series of print ads for the law firm of Womble Carlyle, a bulldog represents the kind of tenacity one looks for in an aggressive attorney who will stick with the case and do whatever has to be done to win. "Law firm clients want litigators who will 'grab your leg and not let go.' On the other hand, they want the same 'vicious' litigator to be gentle with them," said Burkey Belser of Greenfield/Belser Ltd., a Washington DC-based design firm. "For Womble Carlyle clients and prospects, the bulldog represents that dramatic tenacity plus loyalty, flexibility, and all the other positive qualities people associate with man's best friend."

PROJECT	WOMBLE CARLYLE PRINT ADVERTISING
DESIGN FIRM	GREENFIELD/BELSER LTD.
ART DIRECTOR	BURKEY BELSER
DESIGNER	JEANETTE NUZUM
PHOTOGRAPHER	JOHN BURWELL
CLIENT	WOMBLE CARLYLE

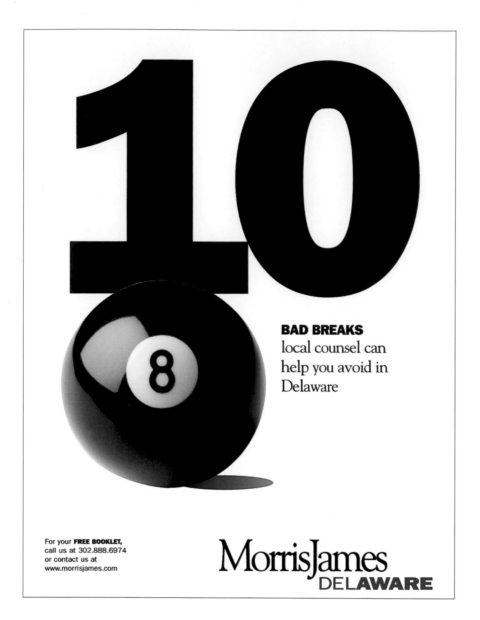

10

BAD BREAKS
local counsel can
help you avoid in
Delaware

For your **FREE BOOKLET,**
call us at 302.888.6974
or contact us at
www.morrisjames.com

MorrisJames
DEL**AWARE**

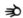 To raise awareness for a Delaware law firm,
Greenfield/Belser Ltd. uses an eight ball—familiar to
pool players who know that to win they need to pocket
all the solid balls below the eight ball and all the
striped balls above it. If a target ball is behind the eight
ball, the player doesn't have a clear shot and runs the
risk of sinking the eight ball and losing the game. The
phrase, behind the eight ball, has become part and par-
cel of the English language and indicates a situation of
risk and potential jeopardy. "Clients of Morris James
will find themselves behind the eight ball without the
intelligent representation Morris James' lawyers bring
to the table," said Burkey Belser.

PROJECT	MORRIS JAMES ADVERTISEMENT
DESIGN FIRM	GREENFIELD/BELSER LTD.
ART DIRECTOR/	
DESIGNER	BURKEY BELSER
CLIENT	MORRIS JAMES

Deleo Clay Title Company wanted a new identity that projected the company's heritage and strength. An illustration of a lion was chosen as the perfect metaphor—communicating not only the strength of the company, but the strength of the product as well. A contemporary rendering of a lion would have conveyed the company's strength, but would have failed to convey its years of experience in the industry. Thus, the illustrator created an image reminiscent of the lions found on a coats-of-arms, which graphically depicts the company's heritage.

PROJECT	**DELEO CLAY TILE COMPANY IDENTITY SYSTEM**
DESIGN FIRM	**MIRES DESIGN, INC.**
ART DIRECTOR	**JOSÉ A. SERRANO**
DESIGNER	**DAVE ADEY**
ILLUSTRATOR	**DAN THORNER**
CLIENT	**DELEO CLAY TILE COMPANY**

Global Graphics: Symbols

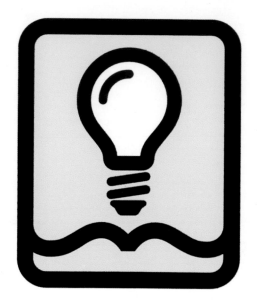

The light bulb has long been used to symbolize a bright idea. A recent advertising campaign for the Yellow Pages positions the commercial telephone directory as an idea book—a source of inspiration for ideas about products, where to shop, where to dine, and much more.

PROJECT YELLOW PAGES LOGO
DESIGN FIRM MIRES DESIGN, INC.
ART DIRECTORS JOSÉ A. SERRANO, BRIAN FANDETTI
DESIGNERS JOSÉ A. SERRANO, MIGUEL PEREZ
ILLUSTRATOR MIGUEL PEREZ
CLIENT YELLOW PAGES

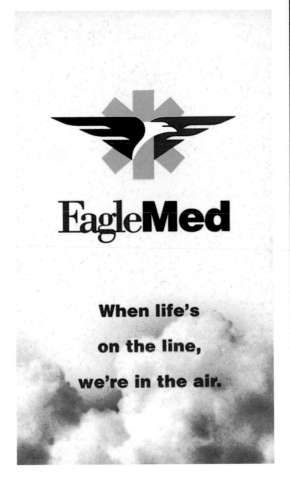

22 · 23

24 Hour Intensive

Care Service

1.800.525.5220

SANFORD C. ROGERS
Public Relations Manager

Tel 1.800.764.3343

6601 Pueblo Road

Mid-Continent Airport

Wichita, KS 67209

Bus 316.946.4855

Fax 316.946.4853

The logo for EagleMed makes uses of two symbols
the universally recognized medical icon, the Star of
Life, behind a contemporary rendering of an eagle,
symbolizing flight, heroism, and strength. "EagleMed's
new identity denotes vigilance and professionalism,"
said Sonia Greteman.

PROJECT	EAGLEMED BUSINESS CARD
DESIGN FIRM	GRETEMAN GROUP
ART DIRECTOR	SONIA GRETEMAN
DESIGNER	JAMES STRANGE
CLIENT	EAGLEMED

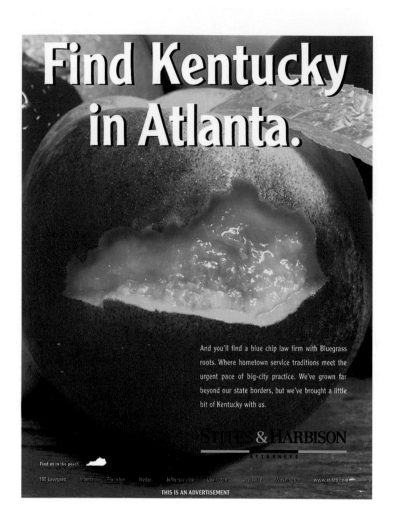

Borrowing on the symbology of New York and its familiar visual metaphor as "The Big Apple," designers likened Kentucky-based law firm Stitles & Harbison's opening of an Atlanta, Georgia, office with the firm taking a bite out of Atlanta—depicted in the advertising as a big peach and the bite as a map of Kentucky. While Atlanta is not called "The Big Peach," the city has long been associated with peaches due to the number of peaches grown in the state of Georgia and surrounding areas. Moreover, dozens of streets, venues, and businesses in Atlanta get their name from the state's association with peaches, including the city's famous Peachtree Road.

PROJECT	STITES & HARBISON ADVERTISEMENT
DESIGN FIRM	GREENFIELD/BELSER LTD.
ART DIRECTOR	BURKEY BELSER
DESIGNER	TOM CAMERON
CLIENT	STITES & HARBISON

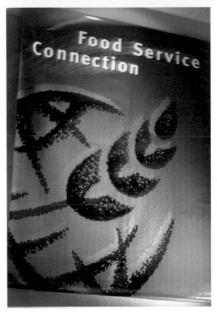

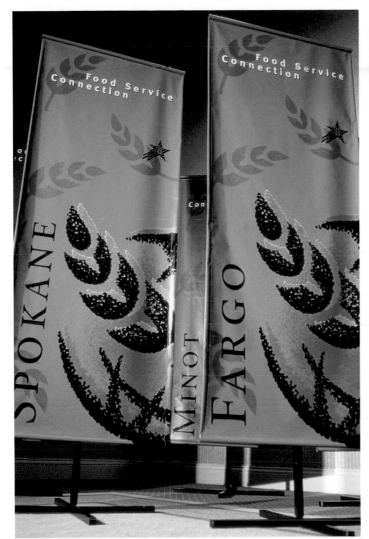

The symbol of a sheaf of wheat, implying the staff of life as well as an abundant harvest, backed by the image of a globe combine to communicate how the Food Services of America partners with vendors worldwide. The imagery was the focal point of the Food Services of America's annual sales conference, a perfect setting to reinforce the organization's strength and position in the food service industry and encourage the sales force to continue the partnership-building they had worked hard at over the previous year.

PROJECT	FOOD SERVICES OF AMERICA CONFERENCE EXHIBIT
DESIGN FIRM	HORNALL ANDERSON DESIGN WORKS, INC.
ART DIRECTOR	JACK ANDERSON
DESIGNERS	JACK ANDERSON, CLIFF CHUNG
CLIENT	FOOD SERVICES OF AMERICA

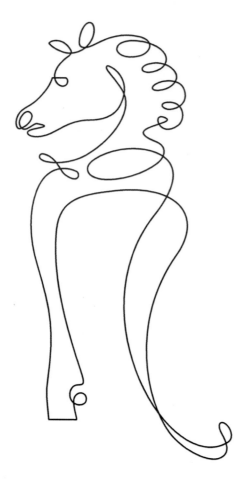
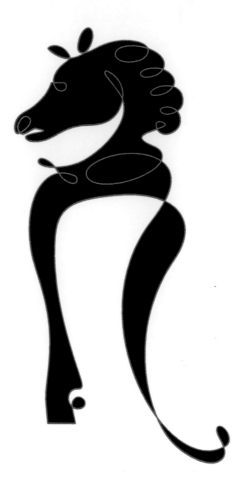

Meryl Pollen used the image of a horse as the identifying graphic for Regal Tea's trademark, stationery system, and packaging. "The logo is based on a chess piece in order to capture a regal posture for the company and to maintain a subtle reference to the *R* through the back leg of the horse," Pollen explained. Pollen created the logo with one continuous line drawing, giving the image a sense of completeness, in keeping with the feeling Regal Tea hopes its customers will experience when drinking the company's teas. The packaging was limited to two colors as a means to save money and also as a color-coding system; additional colors will be added as new products are integrated to the line.

PROJECT **REGAL TEA PACKAGING**
DESIGN FIRM **MERYL POLLEN**
ART DIRECTOR/
DESIGNER/
ILLUSTRATOR **MERYL POLLEN**
CLIENT **REGAL TEA**

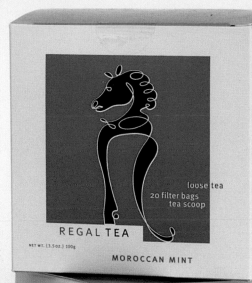

loose tea
20 filter bags
tea scoop

REGAL TEA

NET WT. (3.5 oz.) 100g

MOROCCAN MINT

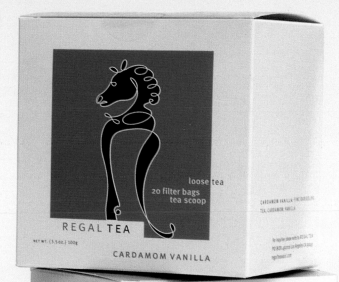

loose tea
20 filter bags
tea scoop

REGAL TEA

NET WT. (3.5 oz.) 100g

CARDAMOM VANILLA

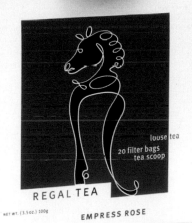

loose tea
20 filter bags
tea scoop

REGAL TEA

NET WT. (3.5 oz.) 100g

EMPRESS ROSE

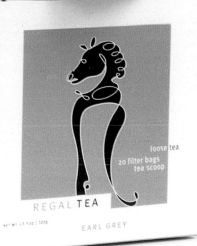

loose tea
20 filter bags
tea scoop

REGAL TEA

NET WT. (3.5 oz.) 100g

EARL GREY

The Motorcycle

Since the end of World War II, the motorcycle has become a universal symbol of rebellion. Even though it was invented decades earlier, its status as a "freedom machine" didn't really take hold until it was embraced by young, disgruntled veterans returning from a gruesome war who could find no reason to return to their pointless jobs and tidy lives. They were joined by disillusioned teenagers and college students looking for a purpose for everything they had witnessed as children.

The first bikers were not limited to the motorcycle gang types portrayed in 1950s films such as The Wild Ones, with their cumbersome Harley-Davidsons and Indians. Lighter-weight motorcycles—called café racers—were equally popular with "les Beats," who wiled away the hours drinking espressos in cafés and coffee houses as depicted in the 1950s French motion picture Orpheus.

From the bohemian lifestyle references of the postwar decade, motorcycles become synonymous with the words "cavalier" and "escapist" during the 1960s. The Hell's Angels bike gangs and the cult classic Easy Rider reinforced the public's understanding that the motorcycle was not meant to be driven by conventional or conservative folk with straight, normal lives; it was and still is the ultimate icon of rebellion.

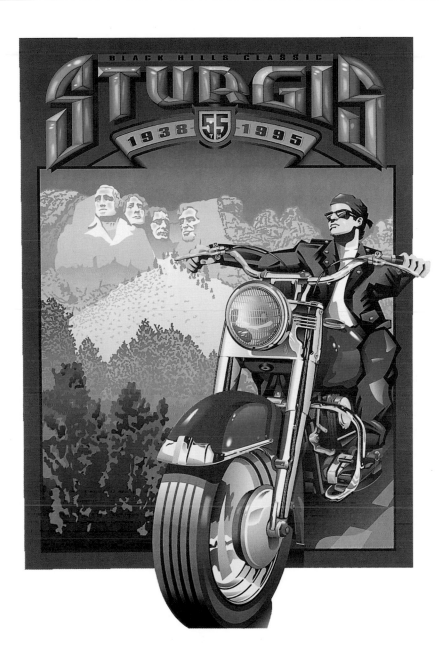

A metaphor for freedom and escape for more than half a century, the motorcycle is the central subject for this poster promoting a classic biker gathering that takes place in Sturgis, South Dakota.

PROJECT **STURGIS PRINT**
DESIGN FIRM **MCCULLOUGH CREATIVE GROUP**
ART DIRECTOR/
DESIGNER/I
LLUSTRATOR **MIKE SCHMALZ**
CLIENT **STURGIS LIMITED EDITIONS**

Canada

Symbols of this young nation reflect diverse cultural influences and wilderness traditions.

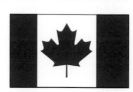

An emblem of two of Canada's major exports—maple sugar and maple wood—the red sugar maple leaf has been used as a symbol of Canada since the early 1900s.

Though often thought of by Americans as being part of the United States (due in part to the world's longest unpatrolled, unguarded border between two countries), Canada is indeed a separate country with a diverse and unique set of images that reflect its culture and heritage. Like its immediate southern neighbor, it is a relatively young nation, and with the exception of Quebec, a former British colony. Settled by France in the early 1600s, Quebec fell under British rule after a decisive battle in 1759, and became one of four founding provinces in the Canadian Confederation of 1867.

As 90 percent of the population lives in the southernmost 10 percent of the country, and the entire population is roughly equal to that of California, symbols of Canada frequently draw upon its hinterlands—from mounties, trappers, and lumberjacks, winter landscapes, and activities such as hockey and skiing, to the maple leaf and its associated products, such as maple syrup and maple sugar candy. Strong French, British, and Scottish influences mingle with those of native Indian cultures to produce a more conservative and surprisingly more European culture than in the United States. Canadian symbols often reflect these influences.

Animals

During the eighteenth and nineteenth centuries Canada's national symbol was the beaver, which represented the young nation's main export—fur. Although it was superseded by the maple leaf in later years, the beaver (for Canadians) is still synonymous with the diverse natural beauty of the Canadian wilderness. A symbol of the icy cold Arctic, the polar bear is another Canadian native, inhabiting the Northwest Territories and the area surrounding Hudson Bay near Churchill, Manitoba. This same animal also appears as a powerful, solitary character in ancient Siberian, Manchurian, and Inuit (Eskimo) myths. Despite its close associations with both Canada and Alaska, in contemporary Chinese culture the polar bear symbolizes Russia.

✦ *Plants*

Appearing on the national flag as well as many other government and corporate logos, the maple leaf is Canada's modern-day national symbol. The maple tree is of course the source of maple syrup and maple sugar, which the country produces for export. Besides appearing on the Canadian flag, three red maple leaves are also placed on the shield of the nation's coat-of-arms, with a lion in the crest holding a fourth leaf in its paw. The leaves are also incorporated into the provincial coats-of-arms for Ontario and Quebec.

✠ *People*

The Royal Canadian Mounted Police symbolize the spirit of incorruptibility, forthrightness, and politeness throughout the world. And like their legendary reputation "The Mounties always get their man," the familiar image of an RCMP officer sitting astride a horse represents unswerving determination against unknown odds. Another personification of the Canadian spirit—the lumberjack—represents a spirit of courage and strength and the will to survive the rigors of life in the wilderness.

◻ *Shapes*

Unique to the Canadian province of Quebec, the French fleur de lis symbolizes the province's francophone roots and the language of its majority; the provincial flag bears four white fleurs de lis on a light blue field. (A slightly darker blue, with gold fleurs de lis, however, is the basis of Bosnia and Herzegovina's flag.)

The totem poles and ceremonial masks carved by native artisans of the Haida, Kwakiutl, and Tlingit tribes are often used as symbols of Canada's Pacific west, which includes the province of British Columbia and portions of the Yukon.

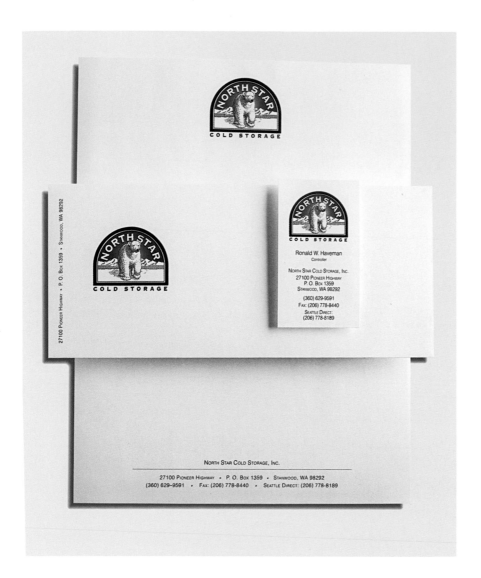

A polar bear symbolizes the icy cold, so Walsh & Associates employed this familiar association in the solution for a cold storage company's logo.

PROJECT	NORTH STAR COLD STORAGE LOGO
DESIGN FIRM	WALSH & ASSOCIATES, INC.
ART DIRECTOR	MIRIAM LISCO
DESIGNER	KATIE DOLEJSI
ILLUSTRATOR	LARRY JOST
CLIENT	NORTH STAR COLD STORAGE, INC.

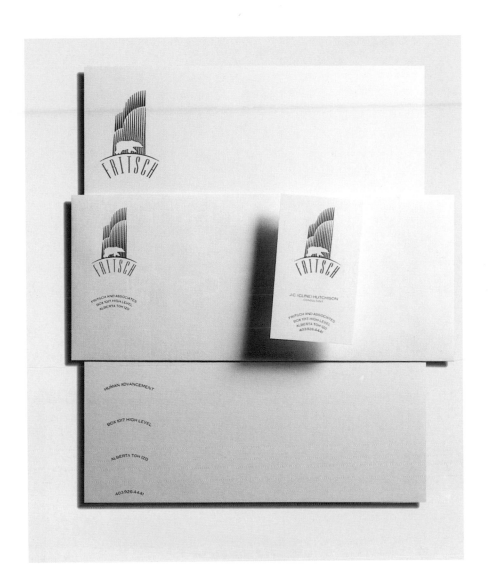

 A representative of the Canadian Arctic, the polar bear is the central figure of this logo designed by Duck Soup Graphics for Fritsch Associates, which is located in the far-northern region of Alberta, Canada.

PROJECT	**FRITSCH ASSOCIATES LOGO**
DESIGN FIRM	**DUCK SOUP GRAPHICS**
ART DIRECTOR/ DESIGNER/I LLUSTRATOR	**WILLIAM DOUUCETTE**
CLIENT	**FRITSCH ASSOCIATES**

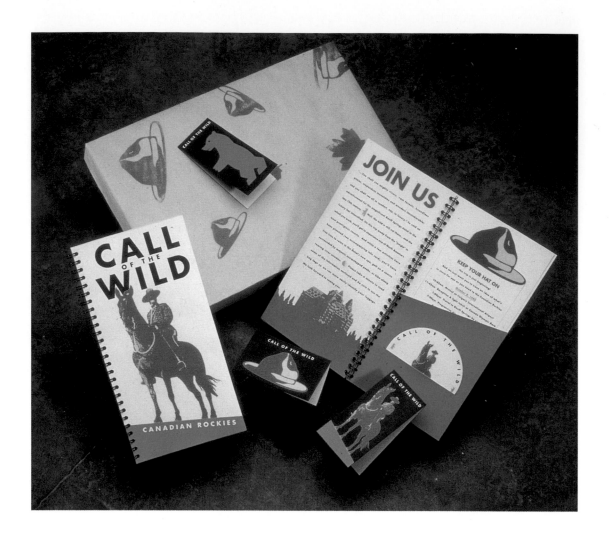

 Utilizing a classic symbol of the Canadian wilderness, Vaughn/Wedeen created this invitation to travel to the Canadian Rockies. This same promotion also applied a grizzly bear and a Mountie's hat as secondary design elements.

PROJECT	CALL OF THE WILD PROMOTIONAL MATERIALS
DESIGN FIRM	VAUGHN/WEDEEN

34 · 35

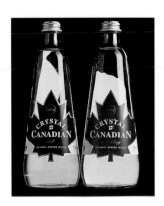

A familiar Canadian icon, the sugar maple leaf shape is used to identify the location of the company and the source of the bottled water.

PROJECT	CRYSTAL CANADIAN SPRING WATER PACKAGING
DESIGN FIRM	CARTER WONG AND PARTNERS
ART DIRECTOR	PHILIP CARTER
DESIGNERS	PHILIP CARTER, TERI HOWES
CLIENT	AC WATER CANADA INC.

WOODBRIDGE
PALLET LIMITED

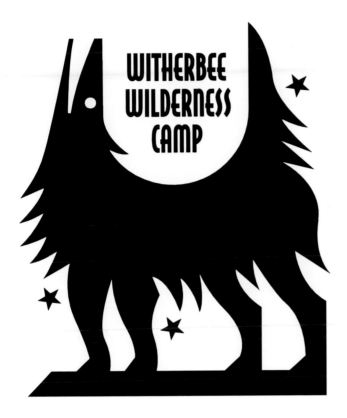

The Wolf

Universal Symbol
THE WOLF IN ALL OF US

In direct contrast to the wolf's wild and predatory image in the United States and Europe, folk tales told in northern China, Siberia, and India depict the wolf as a creature capable of adopting and nurturing abandoned human children. The founders of the city of Rome, Romulus and Remus, were said to have been raised by a wolf. (This image, which originally appeared on ancient Roman coins, has survived for centuries as a symbol for man being nurtured by nature, and civilization being borne from savagery.) Even the Mongol emperor Genghis Khan claimed to be descended from a blue-gray wolf.

The wolf was considered to be an evil predator in the United States and Canada until recently. Folk tales about the "big bad wolf" imported by central European immigrants during the eighteenth and nineteenth centuries did little for the animal's image. But as the wolf's true nature becomes more broadly understood, the wolf is fast transforming into a symbol of the wild and of survival. A complex image, its meaning can be varied, depending on how it's portrayed. For example, portraying a wolf staring head-on can symbolize calm strength and primitive power. However, in this logo, designer Don Weller depicted a howling wolf, which is a symbol of the wilderness and celebration.

PROJECT WITHERBEE WILDERNESS CAMP LOGO
DESIGN FIRM THE WELLER INSTITUTE FOR
 THE CURE OF DESIGN
DESIGNER DON WELLER

Mexico

The Mexican spirit reflects Aztec traditions mixed with rich Spanish Catholic iconography.

The eagle battling with a snake is the emblem of the ancient Aztec capitol of Tenochtitlan, now Mexico City. This metaphor for the war between the sun and the rain serves as the centerpiece of Mexico's national flag.

Combining sophisticated Aztec and Mayan traditions with rich Spanish Catholic iconography, Mexican culture is as diverse as its environment, which ranges from arid desert to humid jungle. Mexico is not as visually patriotic as its northern neighbors the United States and Canada. National symbols such as the flag do not play a key role in visual representations of the country. Instead, historic figures, indigenous plants and animals, and relics of the glorious native past signify various facets of the Mexican spirit.

Mexico's climate ranges from arid deserts to the lush, tropical jungles of the Yucatan peninsula. And its inhabitants are descended from equally diverse cultures. Indigenous tribes with highly sophisticated cultures, such as the Aztecs and Mayans, lived in this region for thousands of years before being conquered by Spanish invaders. Consequently, the already-rich symbolic traditions of Central America were augmented by modified Roman Catholic icons and Hispanic motifs.

Although Pancho Villa and Emiliano Zapata are familiar Mexican figures outside the country, it's not uncommon to see portraits of the Aztec emperor Montezuma II printed on promotional calendars or on building murals in modern-day Mexico and in portions of the southwestern United States. Nor is it rare to find Spanish elements such as bullfighting arenas and ornate Catholic churches.

Animals
Despite the recent branding by a Mexican food chain, the Chihuahua has been as closely linked to Mexico as the burro, the coyote, and the iguana. Compatible with the country's arid terrain, these animals appear to be as fragile as the desert they inhabit. Yet each possesses qualities of inner strength and endurance. The Chihuahua is short, high-strung, and short-haired. Though its appearance is inherently humorous, it was prized for its ability to warn its owners of subtle dangers such as tarantulas and scorpions. The coyote is known for its cunning and for its ability to capture elusive prey such as the roadrunner and the desert rat. The iguana survives by adaptability, seeking out the sun to warm itself while its neighbors search for shade.

Plants
Desert plants such as the saguaro cactus, the agave, and prickly pears are strongly identified with the rugged Mexican terrain. However, maize is also associated with the native tribes that cultivated this vital grain, the source of maza harina—the flour used to make tortillas—prior to Spanish settlement.

MISCOMMUNICATIONS

The Chevrolet Corporation's marketing department discovered it had made a fatal error of judgment in failing to rename a popular American car model before shipping it to dealers in Spanish-speaking nations. The Chevy Nova had all the characteristics of a successful car—sleek lines, a powerful engine, and sporty appearance. However, its name meant literally "doesn't go" in Spanish.

The lush Yucatan rainforests are just one of the symbols of Mexico that bear deep psychological significance in the western hemisphere. The forest in general is often perceived as a symbol of the primeval—of timeless and unspoiled nature. Other plant icons include bananas and banana trees, which are indigenous to the southern regions as well as the neighboring nations of Panama, Nicaragua, and Costa Rica.

People

The dual nature of Mexico's culture is symbolized by three contrasting figures. The image of the Aztec emperor Montezuma II is still employed in the design of calendars, packaging, and even murals seen throughout both urban and rural Mexico. A great warrior and leader until he died during the Spanish invasion led by Hernando Cortés, he still signifies the pride Mexican Indians maintain in their long heritage as descendants of the once-great Aztec civilization. Hispanic Mexicans also revere the symbol of their Spanish-Christian heritage—Nuestra Madre de Guadeloupe (Our Lady of Guadeloupe). This vision of the Virgin Mary first appeared to a converted Aztec named Juan Diego on Tepeyac Hill on December 9, 1531. The Lady of Guadeloupe is commonly found on candlesticks burned in households, as well as in statuary form, to invoke the protection of this nurturing, protective symbol. A more colorful and controversial figure is Emiliano Zapata the revolutionary. Elected leader of his village in 1909, Zapata began recruiting an insurgent army even before the Revolution of 1910, which overthrew the dictator Porfirio Diaz. Links between the dictatorship and the U.S., combined with Mexico's history as a Spanish colony, gave rise to revolutionary nationalism—revolution as defense of the nation—which, like Zapata's credo "It is better to die on your feet than to live on your knees!" is still apparent in the culture today.

Shapes

Hidden deep within the tropical rainforests of the Yucatan peninsula, the ancient stepped pyramids built by the Mayas still stand as unique monuments to the complex civilizations that existed in the region prior to the Spanish conquest. The sun was worshipped as the primary god and these stone edifices helped elevate the high priests, the emperor, and their offerings closer to the sky, where they could be consumed by the sun's rays. The pyramids of the Aztecs and the Mayans signify this close, reverential relationship between the people and the sun.

Lui Jaime of El Caracol, Arte y Diseño employed an oak tree, symbolizing endurance and longevity, in the logo for Voice Tree, a fax-on-demand network.

PROJECT	**VOICE TREE IDENTITY**
DESIGN FIRM	**EL CARACOL, ARTE Y DISEÑO**
DESIGNER	**LUIS JAIME**
CLIENT	**VOICE TREE**

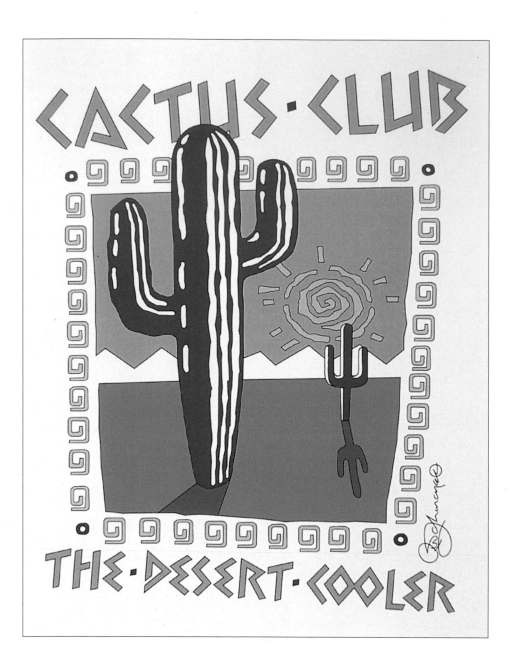

Quenching thirst in the hot desert heat takes on a Mexican flair in this logo designed by Z Works, which employs a cactus to depict an arid terrain.

PROJECT CACTUS CLUB THE DESERT COOLER IDENTITY
DESIGN FIRM Z WORKS
ART DIRECTOR/
DESIGNER/
ILLUSTRATOR RON ZAHURANEC
CLIENT CACTUS CLUB COOLERS

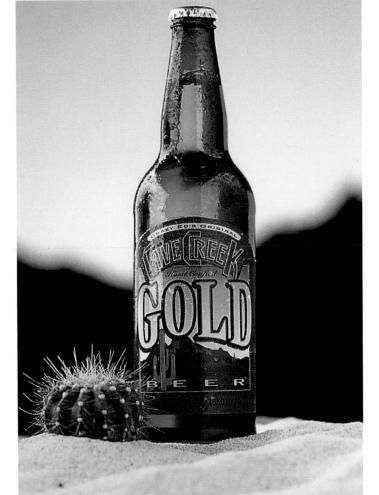

A symbol for Mexico's arid terrain, Tieken Design and
Creative Services used a cactus to convey south-of-the
border for Cave Creek Gold Beer.

PROJECT	**CAVE CREEK GOLD BEER**
DESIGN FIRM	**TIEKEN DESIGN AND CREATIVE SERVICES**
ART DIRECTOR/	
DESIGNER	**FRED E. TIEKEN**
CLIENT	**BLACK MOUNTAIN BREWING COMPANY**

The Caribbean

Palm trees, parrots, indigo, and mystical imagery symbolize a colorful cultural history.

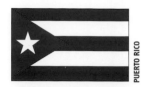

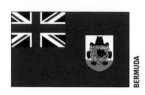

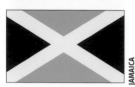

Evoking their colonial roots, the flags of Jamaica and Bermuda both incorporate symbols of the United Kingdom the St. Andrews cross and the Union Jack, respectively. A territory of the United States since the 1800s, Puerto Rico also portrays its heritage in this adaptation of an American flag.

From the day Christopher Columbus first landed on the lesser Antilles in the Caribbean during the late 1400s, European settlers flocked to these tropical ports to find their fortunes in spices, tobacco, cocoa, sugar, and indigo. And European pirates soon followed, looting the rich seaports and vessels filled with gold and other precious treasures, flying their own standards such as the Jolly Roger, which struck fear in the hearts of affluent passengers. But they were not the only outsiders to influence life in the islands. Imported by plantation owners to work the fields, slaves from central and West Africa toiled alongside the conquered Carib Indians. Their shared mystical beliefs about nature created another layer in this unique culture. Voodoo and espiritu symbolism still provide strong imagery in rural portions of Haiti, the Dominican Republic, Cuba, and Jamaica.

The romance of the Caribbean is enhanced by the area's visual associations, particularly with its fauna, flora, and marine life. Palm trees, parrots, and dolphins are just a few of the exotic symbols visitors flock to see as they stroll the white sands under a blazing sun.

Animals

Although they are not exclusive to the tropical forests of the Caribbean, parrots are often associated with these islands. They were frequently pictured as companions to another familiar symbol of the Caribbean the pirate. In fact, the parrot has been employed not only as a symbol of lush jungle environments, it has become just as much a pirate symbol as the skull and crossbones (see pages 000-000). The waters of this region are inhabited by classic marine symbols such as blue marlins, dolphins, porpoises, and manatees (which are thought to have been mistaken for mermaids by early European sailors). Dolphins were linked with the gods Apollo, Aphrodite, and Poseidon by the Greeks. However, the god of ecstasy, Dionysius, was said to change pirates into these intelligent marine mammals.

⊕ *Plants*

Swaying palm trees may signify rest and relaxation—a form of paradise in modern western culture. But for ancient Egyptians and early Christians, these lush tropical trees signified the paradise that comes in the hereafter. It was often coupled with Nike, the goddess of victory, and Hathor, the Egyptian goddess of the heavens, because its straight trunk and lush foliage represented ascent, victory, and rebirth.

☆ *People*

Pirates are the most familiar symbol of the Caribbean, even though most of these men and women were actually European opportunists who had been transported to the islands as workers, settlers, or indentured servants. Blackbeard was just one of the characters who inspired the legends carried back to Europe and North America by the terrified travelers who feared for their lives on the high seas from Nassau and the Bahamas to Puerto Rico and Martinique.

▢ *Shapes*

Sailboats are used in many temperate climates, but these leisure craft are most commonly associated with the sense of relaxation that tourists experience in the Caribbean. Similarly, hammocks represent the laid-back atmosphere found in the Caribbean.

⇒ *Language/Gestures*

Four evocative words that define styles of music and dance unique to the Caribbean also symbolize the region itself mambo, limbo, calypso, and reggae. The mambo was born in Cuba; the limbo, calypso, and reggae come from the shores and mountains of Jamaica. Besides their close connection to vibrant lime green, flamingo pink, and other brilliant tropical colors, all of these words are also associated with free-spirited energy, leisure, and physical vitality.

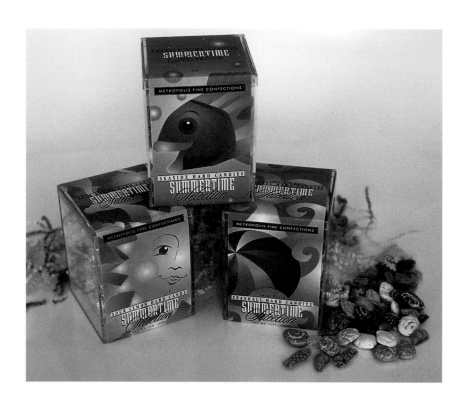

The Design Company employed a familiar metaphor for the Caribbean and tropical recreation—a tropical fish—to convey a seaside message on the packaging for Summertime Seaside Hard Candies.

PROJECT **SUMMERTIME SEASIDE HARD CANDIES**
 PACKAGING
DESIGN FIRM **THE DESIGN COMPANY**
ART DIRECTOR **MARCIA ROMANUCK**
DESIGNER/
ILLUSTRATOR **ALISON SCHEEL**
CLIENT **METROPOLIS FINE CONFECTIONS**

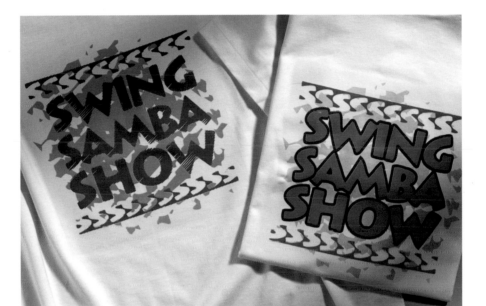

The word samba conveys a sense of liveliness, fun, and gaiety with a Latin American theme without the use of any visuals in this T-shirt design.

PROJECT **SAMBA BAND LOGO/T-SHIRT**
DESIGN FIRM **ANIMUS COMMUNICAÇÃO**
ART DIRECTOR **RIQUE NITZSCHE**
CLIENT **SWING SAMBA SHOW**

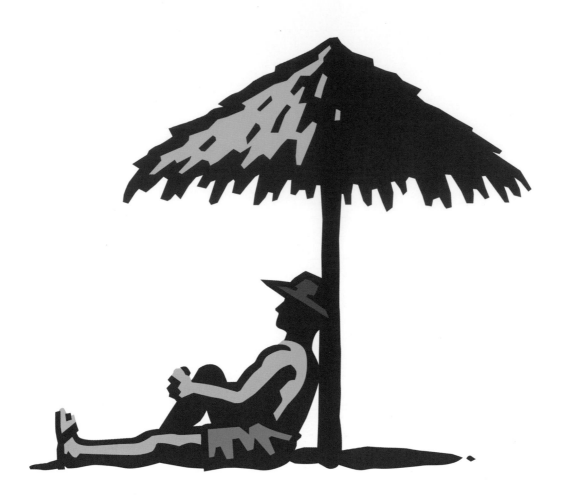

 White sandy beaches, lapping surf, and palm trees are not the only way to convey a relaxed Caribbean or tropical message—Tracy Sabin communicated this same feeling by depicting a beachcomber resting under a thatch umbrella.

DESIGN FIRM **TRACY SABIN GRAPHIC DESIGN**
DESIGNER **TRACY SABIN**
CLIENT **MIRES DESIGN FOR RUBIOS RESTAURANTS/BAJA GRILL**

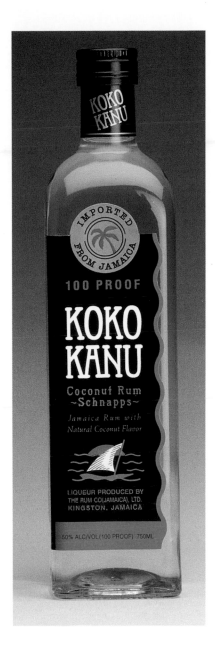

Conveying its tropical origins through the use of a sway-ing palm and a sailboat, Susan Meshberg Graphic Design conveyed the origin of this Coconut Rum Schnapps it is manufactured on the Caribbean island of Jamaica.

PROJECT	KOKO KANU COCONUT RUM SCHNAPPS PACKAGING
DESIGN FIRM	SUSAN MESHBERG GRAPHIC DESIGN
ART DIRECTOR/	
DESIGNER	SUSAN MESHBERG
ILLUSTRATOR	PAUL CALABRO
CLIENT	CARRIAGE HOUSE IMPORTS LTD.

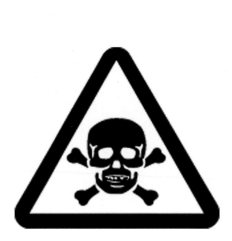

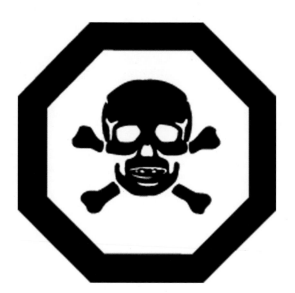

Set within a triangle, the skull and crossbones indicates the contents should be used with rubber gloves and other protective devices.

At the center of an octagon, the skull and crossbones warns users that contents are highly poisonous.

The Skull and Crossbones

Universal Symbol

YO! HO! HO! AND A BOTTLE OF RUM

Rock musician Marilyn Manson drew the image obsessively while he was still in grammar school; and the heavy-metal band Motorhead employed a fanged and chained variation on the front cover of their *March or Die* album. The skull and crossbones (affectionately called the Jolly Roger) has been a symbol of nihilistic radicals from eighteenth-century pirates to twentieth-century bikers, punks, and gothics.

The early twentieth-century incarnation of the skull and crossbones as a warning label has similar levels of meaning. Set within a triangle, the Jolly Roger indicates the contents should be used with rubber gloves and other protective devices. Enclosed in a diamond, it suggests the user needs eye goggles in addition to gloves and clothes. At the center of an octagon, the Jolly Roger warns users that contents are highly poisonous, containing at least ten percent petroleum distillates.

Making its first recorded appearance in the Western Hemisphere during the sixteenth century, the skull and crossbones was a decorative motif carved on tombstones at places like Exeter and Salisbury cathedrals in England. Symbolizing mortality, the skull and crossbones and other images, such as the hourglass, scythe, and winged skull, became common sculptural elements on eighteenth-century tombstones, memorials, and mausoleums. It was also a popular "badge" among pirates like Black Bart, Captain Kidd, and Blackbeard. Before 1700, these seagoing freebooters flew a red banner called a bloody flag on the main masts of their stolen frigates. But the Jolly Roger eventually became synonymous with buccaneers and pirates, especially after the publication of Robert Louis Stevenson's novel *Treasure Island*. Surprisingly, it was an almost welcome sight to pirates' victims, suggesting that the brigands would take prisoners—as opposed to the bloody flag, which meant that no one would be left alive.

However, the skull and crossbones actually has positive connotations high in the Himalayas, in places like Tibet and Nepal. Ekajata is one of the most powerful deities worshipped by followers of the Vajrayana form of Buddhism. Dressed in a tiger skin, wearing a garland of skulls, and carrying a skull filled with blood and a "chopper made from two human femurs," this gruesome visage with prominent teeth, a protruding tongue, and a demonic laugh has a mantra which if heard by a mortal will free him or her from all obstacles and improve prospects for good fortune. In the aftermath, his or her enemies will be destroyed and the person will become religiously inclined.

The skull and crossbones has been a symbol of nihilistic radicals from eighteenth-century pirates to twentieth-century bikers, punks, and gothics.

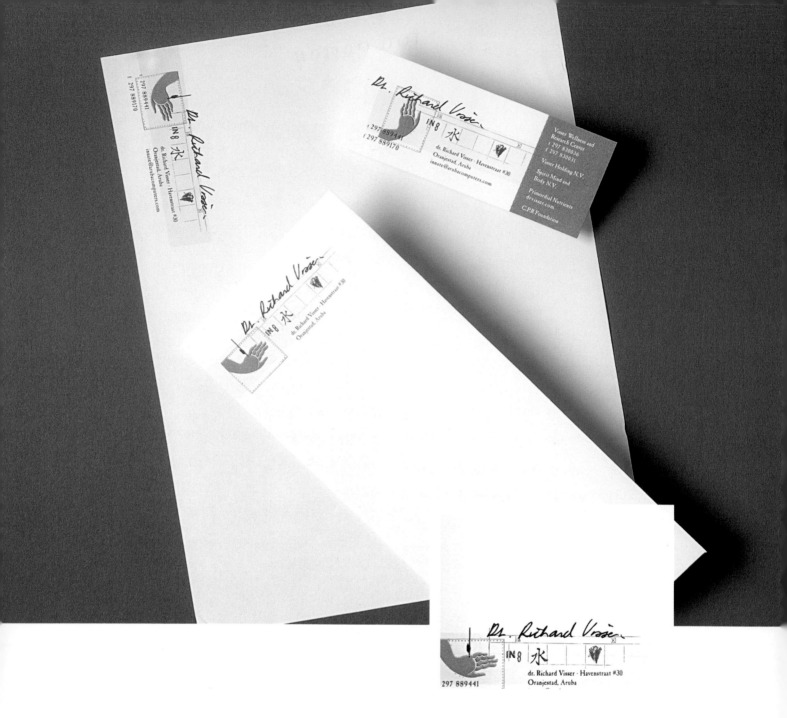

Miriello Grafico's Chris Keeney captures the essence of the Visser Wellness and Research Center—dedicated to treating the spirit, mind, and body—with this identity system that uses four symbols to tell a story. The hand symbolizes healing through touch and support; IN8 is a graphic abbreviation for the word innate; the Chinese character stands for water, which Kenney derived from the practice of feng shui and its influence on ancient Chinese medicine; and the heart symbolizes the spirit and the energy of the body, which cannot be seen or touched.

PROJECT	**VISSER WELLNESS AND RESEARCH CENTER IDENTITY**
DESIGN FIRM	**MIRIELLO GRAFICO, INC.**
DESIGNER	**CHRIS KEENEY**
CLIENT	**DR. RICHARD VISSER**

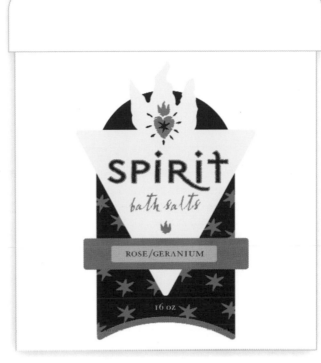

The image of the heart, flame, and star in this logo is derived from old Catholic symbology and is called the Sacred Heart of Jesus. "The story behind the system is about a catholic nun who has a vision of Jesus opening himself and showing his heart to the nun," said Chris Keeney, who designed the logo. "The flame symbolizes love or passion and the star in the middle represents blood, which symbolizes pain. The symbol is common in Latin American culture and some people believe that by bearing it, it will bring them luck or alleviate suffering." With this background in mind, the imagery is the perfect symbol for a company in Aruba that manufactures products that focus on wellness and health of the mind, body, and spirit.

Project	Spirit Logo
Design Firm	Miriello Grafico, Inc.
Designer	Chris Keeney
Client	Spirit

South America

Ancient symbols and indigenous influences augmented by modern Roman Catholic and Hispanic motifs

Like its northern neighbor the vast continent of South America is a culturally and visually diverse land mass. From the dense rainforests of Brazil and the deserts of Chile to the thick pampas of Argentina and the snowcapped mountains of Patagonia, it is difficult to identify a single terrain that symbolizes the entire continent.

South America's unique animals inspired British adventurer Charles Darwin to formulate his theory of natural selection while visiting the Galapagos Islands off Ecuador. The world's largest raptor, the Andean condor, and largest snake, the anaconda, as well as llamas and alpacas, are just a few of the many South American animals that are found nowhere else on earth.

The architecture and sculptures of the ancient Incas provide as much visual heritage to South America as the ranches owned by the gauchos, who are often direct descendants of Spanish settlers. The influences of German, Italian, Portuguese, and Irish settlement can be found in the Bolivian highlands and the Venezuelan jungles as well as the tango clubs of Buenos Aires and the streets of Rio de Janeiro during Carnivale.

Argentina

Much of Argentina's visual identity reflects Christian iconography and its own European roots.

The stylized sun in the center of Argentina's flag represents the sun that shone on May 25, 1810, the day when the Argentine independence demonstrations began.

The lush grasslands of Argentina's pampas remind visitors more of eastern Spain and southwestern France than of South America. The Argentine people themselves—descended primarily from Portuguese, Italian, German, Spanish, and Irish settlers—similarly have more in common with their European cousins than with their indigenous neighbors. Even the country's major industries—cattle, horse, and sheep ranching—have European roots.

Consequently, much of the nation's visual identity comes from Christian iconography and European customs. The result created two unique symbols of passion and pride: the tango and the gauchos. This essential Argentine spirit was also expressed in the figure of dictator Juan Peron's wife Eva, who is still revered by the poor and working classes of this vast nation.

People

The gauchos have been a symbol of Argentine pride and honor since the nineteenth century. These skilled horsemen of the pampas reflect the same virtues in this South American nation as the cowboys of the United States and Canada. But unlike their northern counterparts, gauchos are not depicted with six-shooters, ten-gallon hats, and lariats. Instead, they are noted for their flat gaucho hats, billowing white shirts, decorative silver daggers, and bollos.

Tango dancers represent the passionate side of the Argentine spirit. Invented in the smoky cafés of Buenos Aires during the mid-1800s, the tango has become a universal symbol of open sexuality and romance.

The most revered symbol of modern Argentina in the past half century was Eva Peron. Wife of dictator Juan Peron, Eva (Evita) represented maternal compassion and care. Since she came from the poverty-stricken countryside, she also symbolized the ability of the poor to rise above their station and to achieve greatness. And although the theme of class struggle and the fight for liberation is found in other South American figures, such as Che Guevara, Evita is still its most powerful type.

Animals

The largest of the world's vultures, the Andean condor, was revered by both the Aztecs and the Incas as a sacred creature, symbolizing longevity and old age. Andean condors were believed to make thunder with the flapping of their wings (whose span can exceed ten feet). Their feathers were used in shammanistic rituals to heal the sick.

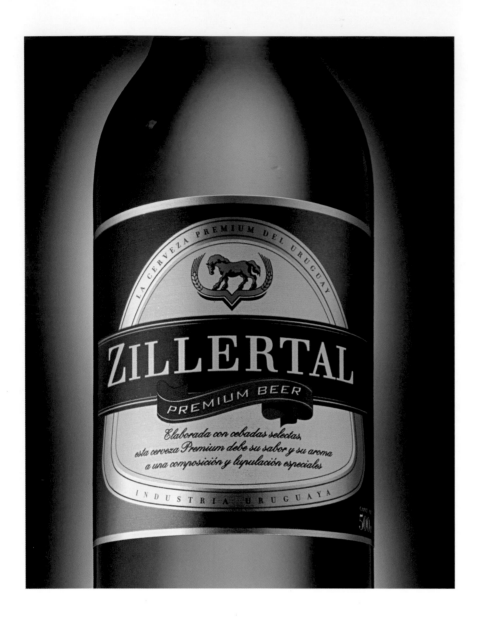

F.N.C. manufactures Zillertal beer in Uruguay and markets it throughout South America. "In the Uruguayan market, Zillertal is considered to be a strong beer with an Austrian heritage. The strength of the beer is represented by the image of the horse," said Carlos Avalos, a designer based in Argentina. "To understand this, one would have to relate to the tradition that horses have in the southern corner of America where horses have always represented freedom, wilderness, and strength."

PROJECT ZILLERTAL PACKAGING
DESIGN FIRM INTERBRAND AVALOS & BOURSE
ART DIRECTOR CARLOS AVALOS
DESIGNER DIEGO GIACCONE
CLIENT F.N.C. (FÁBRICAS NACIONALES DE CERVEZA)

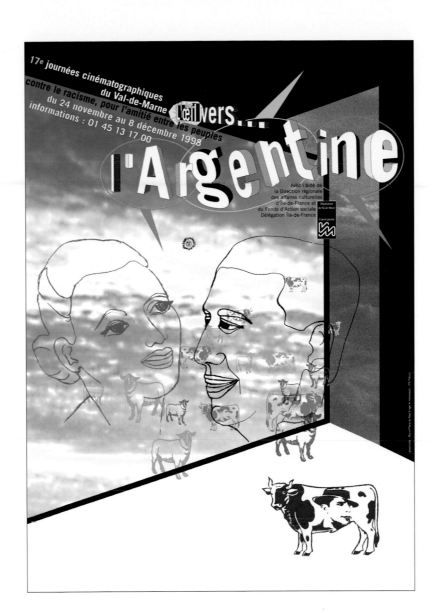

 Long before the television drama, stage musical, and the subsequent film version of *Evita* catapulted Eva Perón to celebrity status, Maria Eva Duarte de Perón was recognized throughout the world as the powerful and influential wife of Argentine president Juan Perón. She died in 1952 of cancer at the age of 33. Since her death, she has inspired numerous retellings of her rise to fame and has generated a cult following. In life as in death, she has come to stand as a national symbol of Argentina. As a result of this notoriety, she is the perfect symbol to use on this poster promoting a film on Argentine cinema in France, pictured here with Carlos Gardel, an Argentine singer and actor, celebrated throughout Latin America and widely associated with the tango.

PROJECT — L'OEIL VERS...L'ARGENTINE POSTER
DESIGN FIRM — MURIEL PARIS ET ALEX SINGER
ART DIRECTORS/
DESIGNERS — MURIEL PARIS ET ALEX SINGER
CLIENT — MAISON DES YEUNES ET DE LA CULTURE
"LA LUCARNE"S À CRÉTEIL

The Moon
and the Star

Closely associated with the feminine side of nature—passive and nurturing—the Moon is symbolically juxtaposed with the aggressive, powerful, masculine Sun in most of the world's cultures. In the Near East and North Africa, however, the Moon has also been a symbol of wisdom for centuries. The Assyrian Moon goddess, Sin, was also the deity representing wisdom. Thoth or Isis was the ancient Egyptian moon goddess who presided over learning. But modern western cultures have seemingly adopted the Jewish tradition, in which the Moon represents the nocturnal (dark) world, the afterlife, and fertility.

The crescent moon appears to have evolved a unique iconography. Early Christians associated this lunar phase with the Virgin Mary, who was often portrayed standing on a crescent moon. It was used as a symbol of victory over hostile forces by the Austro-Hungarians in the 1400s when they defeated the Turks, whose military emblem was a half-moon.

Adopted from the Ottoman Turks, the crescent moon was employed in European heraldry as late as the 1700s as a symbol of prosperity and growth. These days, the crescent moon is generally associated with the Islamic religion, particularly with Sunni Muslims. It is a key element in the flags of Muslim nations such as Algeria, Azerbaijan, Comoros, Malaysia, Maldives, Mauritania, Pakistan, Singapore, Tunisia, Turkey, Turkmenistan, and Uzbekistan.

In Islamic tradition, the moon and star play significant roles. When the prophet Abraham was a child, he spent the first years of his life evading King Nimrod, who had been told that he would lose his kingdom to Abraham. He lived in a cave until fifteen years later, when his mother led him outside under the protection of the angel Gabriel. The first thing he saw was the evening star, which he thought was the Supreme Being. But the star dimmed and Abraham swore he would never worship something that dropped from sight. The same thing happened when he saw the moon. This ultimately led Abraham to worship the being that created these luminous celestial bodies.

Regarded as a symbol of supremacy in modern western cultures, in Judaic tradition the five-pointed star represents heavenly occurrences. In Jewish cosmology, each star has a guardian angel and is the physical manifestation of a heavenly spirit. In Islam, groups of stars were also said to represent the numerous descendants of Abraham. In the Incan, Aztec, and Chinese traditions there are similar connections between stars and departed human spirits.

Early Christian depictions of the Virgin Mary featured her wearing a crown of stars. Roman Catholics interpreted Mary's Hebrew name, Miriam, to literally mean Star of the Sea. Surrounded by eight beams of light, the Star of Bethlehem is a familiar figure for Christians everywhere. But this association is also mentioned in the Apocalypse, in which Christ is called the "bright and morning star" This reference was probably the basis for the five-pointed star surrounded by light beams used in freemasonry to signify the light of the spirit.

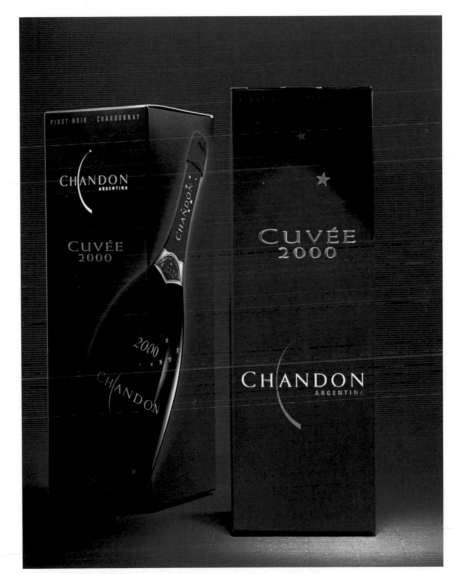

To commemorate the new millennium, Chandon's Cuveé 2000, a special vintage of sparkling wine, required an equally special packaging treatment. In this case, the imagery relies on the symbol of a shooting star and a sliver of a new moon, signifying a beginning. "Stars are very much related to champagne," said Carlos Avalos, art director at the Argentina design firm of Interbrand Avalos & Bourse. "According to legend, Abate Pierre said 'I'm drinking stars,' the first time he tried champagne." Avalos chose a rich blue for the color palette to give the product prestige, particularly in Argentina where the product was marketed and where blue is considered a premium color.

PROJECT **CUVEÉ 2000 PACKAGING**
DESIGN FIRM **INTERBRAND AVALOS & BOURSE**
ART DIRECTOR **CARLOS AVALOS**
DESIGNER **GUILLERMO ANDRADE**
PHOTOGRAPHER **TORRES FOTOGRAFIA**
CLIENT **BODEGAS CHANDON**

Brazil

From the lush rainforest to the colorful Carnivale, beauty is a key element to the Brazilian visual tradition.

The center of Brazil's flag represents a stylized version of the southern sky that embraces this huge nation. The twenty-three stars depict its states, which are united by the words "ordem e progresso," order and progress.

The reality of the vast, forbidding Brazilian rainforests is slowly fading into the past. But these towering jungles remain a symbol of Brazil's majestic natural beauty and have recently become an international symbol of the need for worldwide ecological responsibility.

Beauty is a key element to the Brazilian visual tradition. Descended from Portuguese, Spanish, Carib Indian, and indigenous natives, the people who dwell in the country's major cities, such as Rio de Janiero, Sao Paulo, and Brazilia, are themselves recognized types of physical (and some might say carnal) beauty. Especially when dressed in the glittery and skimpy costumes worn during Carnivale— a celebration that takes place the day before the first day of the Lenten season, Ash Wednesday.

People

The samba dancers that parade through the streets of Rio de Janeiro during Carnivale are the most potent symbols of the Brazilian spirit. Brazilians' reverence for physical beauty and youth is renowned. (Nowhere else on earth will you find as many plastic surgeons and such inexpensive cosmetic surgery!) With the vivid colors of their costumes, the glitter and flash of the props and floats, and the gyrations that accompany the samba's simple steps, these dancers have become typical of tropical festivity.

Animals

South America is home to one of the world's largest snakes, the anaconda, which is said to grow up to twenty-five feet in length. A symbol of the earth itself in cultures such as the jungle tribes of the Amazon and the Incan civilization of the Andes, the snake signifies carnal knowledge in Christian

MISCOMMUNICATIONS

To promote the use of their foun-
tain pen ink, called Quink, the
Parker Pen company employed
the slogan: *Avoid embarrass-
ment—Use Quink*. It was a hit in
the United States and Canada;
but when the marketing depart-
ment prepared it for presentation
to a Spanish-speaking audience, it
was translated as: *Evite embara-
zos—use Quink*. Unfortunately,
this confounded potential con-
sumers because the slogan said:
Avoid pregnancy. Use Quink.

58 · 59

lore and modern psychology. Despite its negative connotations in many parts of the world, this rep-
tile is revered as a symbol of wealth in China and a guardian of the earth's treasures in India. Exotic
bird and wildlife is also symbolic of the region and can be found in the Amazon rainforest.

Shapes
Looming above the outsized costumes and floats of Rio's Carnivale and the psychedelic, black-
and-white inlaid patterns in the sidewalks along Ipanema Beach is the familiar shape of
Sugarloaf mountain. A unique stone mound towering over the city, beaches, and harbor, and
topped with a scenic overlook accessible by aerial tram, it has appeared in countless films and
photos, and is as distinctive a feature as New York's Statue of Liberty or Paris's Eiffel Tower.

Plants
The exotic flora and fauna of the rainforest are symbolic of Brazil, but these plants and its majestic
trees have come to represent an ever-growing save-the-environment, save-the-rainforest aware-
ness campaign. The cry has arisen as increasingly the rainforest is cut down to make way for
industrial expansion and the export of its hardwoods.

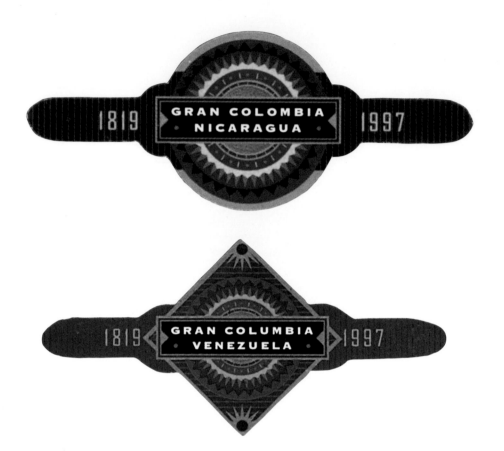

 The woman in native dress who distinguishes this brand identity exudes an exotic allure and "her connection to the land infuses this product with attitude and strength," said Sonia Greteman. "There's no doubt that these are premium cigars you'd be proud to give." The color palette also goes far to reflect Central America's warmth and rich heritage.

PROJECT GRAN COLUMBIA BUSINESS CARDS
 AND TABACOS CIGAR PACKAGING
DESIGN FIRM GRETEMAN GROUP
ART DIRECTOR SONIA GRETEMAN
DESIGNERS JAMES STRANGE, CRAIG TOMSON,
 SONIA GRETEMAN
ILLUSTRATOR SONIA GRETEMAN
CLIENT GRAN COLUMBIA

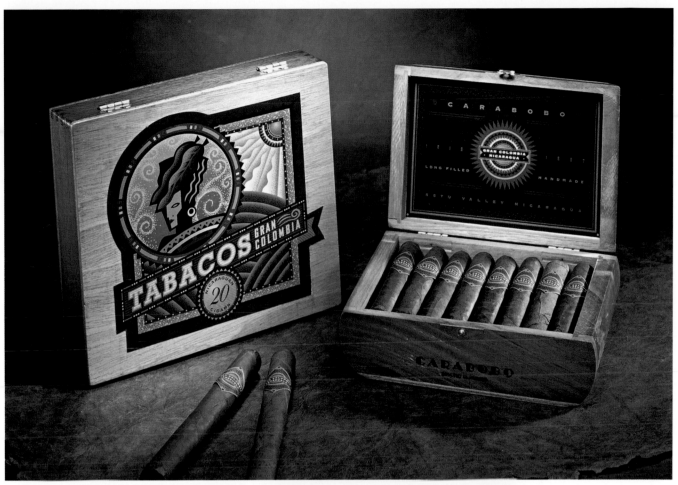

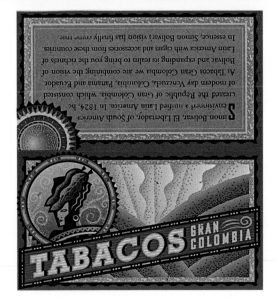

TABACOS GRAN COLOMBIA

PREMIUM CIGARS FROM
CENTRAL AND SOUTH AMERICA

HUMIDORS AND ASHTRAYS CONSTRUCTED OF
REFORESTED TEAK OR MAHOGANY —
HANDMADE BY CRAFTSMEN IN COSTA RICA

3786 DEKALB TECHNOLOGY PARKWAY
ATLANTA, GEORGIA 30340 • TEL (770) 455-0303
FAX (770) 390-9617 • E-MAIL TGC7@AOL.COM

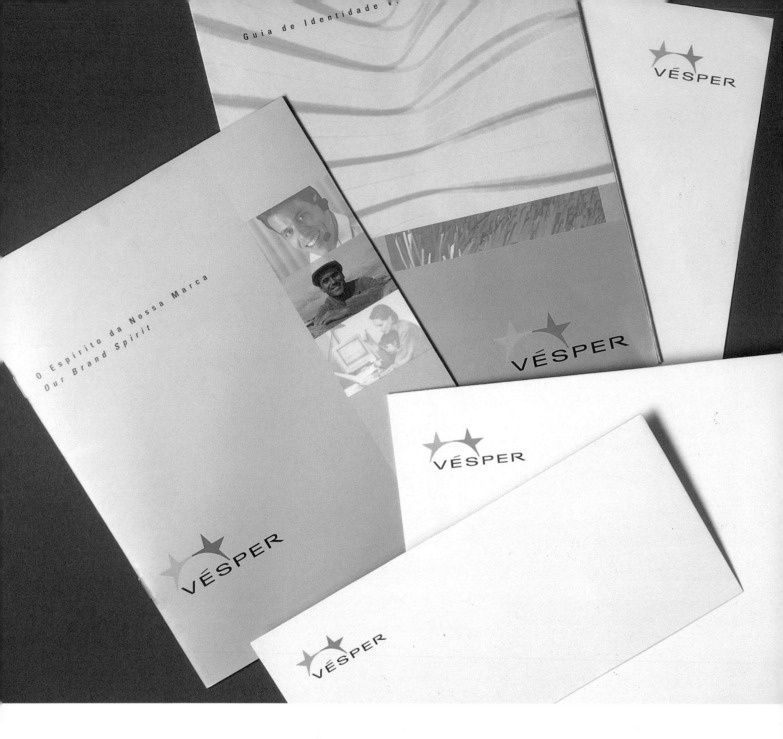

To communicate that Vésper, a new telecommunications company, is different, efficient, innovative, and trustworthy, designers developed the company's name and visual identity—featuring stylized stars that are joined to appear as though they are spanning the globe—in this logo treatment that runs throughout the company's marketing materials.

PROJECT VÉSPER CORPORATE IDENTITY
DESIGN FIRM ANA COUTO DESIGN, ADDISON
 BRANDING AND COMMUNICATIONS
CREATIVE
DIRECTORS ANA COUTO, PHIL SEEFELD,
 LINDON LEADER
DESIGNERS LUCIANA PINTO, CHRISTIANA NOGUEIRA, NICK
 BENTLEY, ROSS ROSSTOCAR, MIKE ZUCHSWORTH
CLIENT VÉSPER

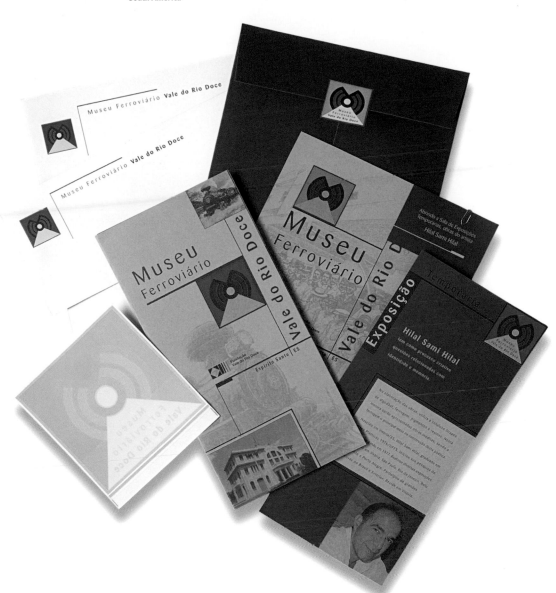

62 · 63

Several symbols can be used to represent a train, but this image of the headlight of an old locomotive, may be one of the best—at least, the most contemporary and eye-catching with a wide-ranging appeal. Ana Couto Design created the logo in response to the proactive community work of its client, a Brazilian exporter of iron ore, which restored an old train station and converted it into a museum. The logo had to appeal to not only corporate and industrial markets, but the public, the press and the residents along the railroad as well. "The creative work was focused on launching the Museum for a broad target audience," explained Ana Couto. "The resulting material is light and joyful, establishing an emotional link with the target market."

PROJECT	MUSEU FERROVIÁRIO VALE DO RIO DOCE (VALE DO RIO DOCE RAILWAY MUSEUM) IDENTITY
DESIGN FIRM	ANA COUTO DESIGN
CREATIVE DIRECTOR/ DESIGNER	ANA COUTO
CLIENT	COMPANHIA VALE DO RIO DOCE

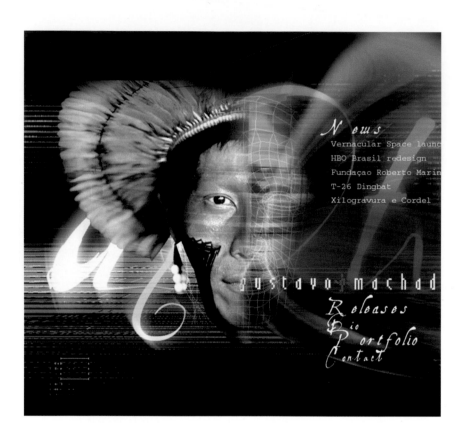

 In his own words, Brazilian designer Gustavo Machado is "a person who appreciates his culture." So it's no surprise that he integrates his culture with his talent for design in a Web site that promotes his expertise throughout the wosrld. "Brazil is a nation of contrasts," he said, citing the opening image on his home page: a man that is half native, in a traditional Brazilian headdress, and half technology.

PROJECT GUSTAVO MACHADO WEB SITE
 (WWW.GUSTAVO-MACHADO.COM/ENGLISH)
DESIGN FIRM ANTI-MATÉRIA DESIGN
ART DIRECTOR/
DESIGNER/
COPYWRITER GUSTAVO MACHADO
CLIENT GUSTAVO MACHADO

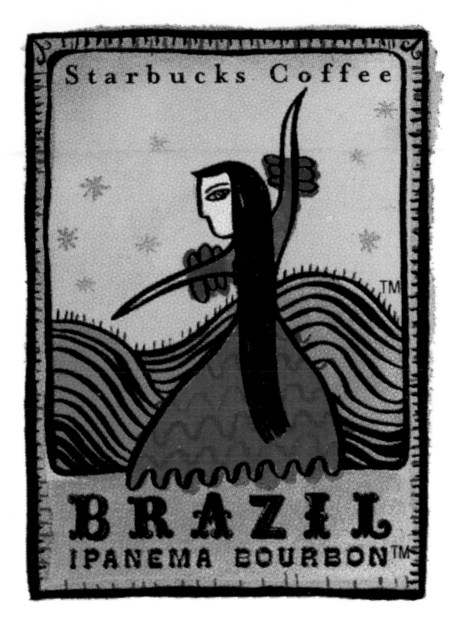

 A Brazilian woman in traditional clothing dancing the samba, a famous dance that comes from Brazil, stands in front of the mountains where the coffee plantations are located. Aside from the obvious symbology of the native dress, the line art illustration in this Starbucks logo also symbolizes the region—featuring a simple, primitive quality that is characteristic of Latin American artwork. The choice of bright colors echoes Latin American clothing and architecture.

PROJECT	STARBUCKS COFFEE BRAZIL IPANEMA BOURBON™ LOGO
DESIGN FIRM	STARBUCKS DESIGN GROUP
ART DIRECTOR	MICHAEL CORY
DESIGNER/ ILLUSTRATOR	MARTINA WITTE
COPYWRITER	STEPHANIE VANDEVACK
PRODUCTION MANAGER	ANN STEVENS
CLIENT	STARBUCKS COFFEE COMPANY

Europe

The cultures of Europe have spread their influence across the entire globe.

From the Americas to Africa, Asia, and Australia, there are few corners of the world where European adventurers have not already stepped and left some cultural mark. Ancient Greeks led by Alexander the Great forged a long road east to India, where they established settlements along the Indian Ocean and influenced both science and architecture throughout the region. Roman legions led by Julius Caesar and others staked their claim as far west as the British Isles, creating highways that stretched from the chalky cliffs of Dover to Hadrian's Wall along the Scottish border.

Centuries after barbarian invasions crippled and crushed the Roman empire, Italian explorers such as Marco Polo and Christopher Columbus led the way for a second European conquest of the world. Italian merchants, Spanish conquistadors, and Portuguese traders led the way towards colonization and conversion of the new worlds that had been discovered. French, Dutch, German, and British business concerns quickly followed, seeking their fortunes in gold, diamonds, tea, and spices.

Each European nation has its own unique iconography, expressing centuries-old myths and superstitions. And although the United States and Japan have exerted a stronger influence on twentieth-century culture, the European nations are still viewed as international symbols of civilization and Christianity despite the fact that civilization came later to western Europe than to other parts of the world, and that European Christianity embeds a variety of pagan symbols within its iconography.

England, Scotland, and Ireland

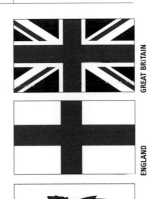

The regal lion and other British icons reflect a reputation of civility and social propriety.

Civility, volatility, and economy are three words that best characterize the people of the British Isles, which include England, Scotland, Wales, Ireland, and Northern Ireland. England has been associated with civility and social propriety since the days of Queen Victoria. British explorers combed the high seas in search of new sites for colonization. Some adventurers were no more than pirates, sanctioned by and serving under the name of their king or queen. Two notable examples are Sir Francis Drake and Captain James Hawkins.

But it was during the Victorian era that England gained its reputation as a place where adherence to daily routines such as high tea and dressing for dinner were mandatory. Congeniality, modesty, and rationality were prized in the same way bravery, courage, and devotion were treated in other lands. It's no wonder that figures such as the emotionless Beefeater, the logical Sherlock Holmes, and the calculating James Bond are standard British icons.

Irish iconography often reflects piety or the stereotyped "fiery" Celtic personality.

By the same token that England is the symbol of civility, Ireland is internationally known for its tall tales and devotion mixed with volatility. The Blarney Stone attests to the Irish talent for weaving and narrating tales about mythical beasts and beings. And some of the country's most famous writers—George Bernard Shaw, Dylan Thomas, and Oscar Wilde—are further proof that this association is not unfounded.

The Irish embraced Catholicism with extreme devotion after Saint Patrick converted the nation from the Celtic practice of sun worship. But Irish piety is coupled with emotional volatility. A polar opposite of the passionless British, the Irish are known for fist-fighting, rowdiness, and rough-housing. The champion Irish boxer John L. Sullivan and the Fighting Irish of Notre Dame University are just two figurative examples of how this iconography emigrated to the United States during the nineteenth-century potato famine.

The Scots' lyrical spirit is a mix of the cool British persona with icy Scandinavian passion

Combining the cool British persona with icy Scandinavian passion, the kilt-wearing Scots symbolize austerity, thrift, and frugality throughout the world. It is not uncommon to see tartan plaid

The United Kingdom's Union Jack represents four nations England, Scotland, Wales, and Northern Ireland. Ireland has a tricolored banner representing its Catholics (green) and Protestants (orange) united in peace (white).

used as a visual element when a bargain or special deal is being portrayed. But thrifty does not automatically mean miserly. The Edinburgh-born millionaire Andrew Carnegie admitted that his Scottish upbringing helped him become wealthy. A hard-work ethic and a knack for finding the best deal were the keys to his success. But he didn't hide his riches in his mattress and live on oatmeal. Carnegie's philanthropy spread across two continents. He established free public libraries and playgrounds with his fortune, refusing to die a rich man.

Like their Celtic neighbors the Irish, the Scots' lyrical spirit is concealed beneath a spartan exterior. The poet laureate Robert Burns often spoke the praises of the heather-and-thistle-filled hillsides as well as the long fight for Scottish independence from British rule. Scotland is also the birthplace of whiskey and golf—simple pleasures enjoyed by the successful and the affluent.

♞ Animals

Closely associated with strength, dominion, and royalty, the lion is one of the national symbols of the United Kingdom—which includes England, Scotland, Wales, and Northern Ireland. On the nation's coat of arms, this regal beast is paired with a symbol of purity, the unicorn (pages 000-000). The lion has long been a symbol of dominion in many cultures. Despite the fact that the male lion is, in truth, a relatively non-aggressive predator who sleeps at least twenty hours a day, it is a primary symbolic figure even in places like Britain where it may never have lived in the wild. Combining concentrated energy with remarkable self-control, the lion symbolizes the sort of masterful yet serene power that is also idolized in Great Britain. In English heraldry, the mighty lion is presented in a rampant posture—standing erect on its hind legs or simply with a front paw raised.

Several types of dogs have become international emblems of the Scottish Highlands: the Scottish Terrier, the West Highland Terrier, the Collie, and the Border Collie. The Scottish and West Highland Terriers have been employed not only as symbols of Scotland, but of a blended scotch whiskey called Black & White. Tenacity, sturdiness, and dedication to hard work are exemplified by all of these dogs, which specialize variously in hunting and herding.

♟ People

A seemingly motionless sentinel, the Beefeater is a familiar sight to tourists visiting London's Buckingham Palace. He has become not only a symbol of London, but a personification of rigid adherence to tradition and a stiff-upper-lipped stance toward life.

Although neither person ever really existed, the nineteenth-century private detective Sherlock Holmes and the twentieth-century superspy James Bond continue to personify the ultimate British male throughout the world. Created by Sir Arthur Conan Doyle, Sherlock Holmes symbolized all that was considered virtuous in Victorian England. He was logical, well educated, and urbane. Ian Fleming's James Bond epitomized the calculating, almost cruel nature of the modern British male. Educated at Cambridge and Oxford, Bond applied his intellect in direct connection to his physical abilities. When he wasn't outsmarting power-mad villains bent on world domination, he was sating his discriminating lust for food and drink and pleasure.

Redheads are also typical Irish symbols. In many cultures, redheaded people are considered to be emotionally volatile, possessing fiery personalities, moved to tears by a song, to giddiness by a dance, and to war by a misplaced comment. The same holds true in Ireland.

THE MIGHTY OAK

The mighty oak tree is a salient feature of many European traditions. Symbolizing endurance and immortality, oak trees were believed to be struck by lightning more often than other trees. The Greek god of lightning and the heavens, Zeus, communicated his will by rustling the oak leaves in the grove at Donona. Nymphs called dryads were said to inhabit the trees.

Ancient Scandinavians planted oaks in reverence to Thor, their god of thunder. Romantic poets and composers likened oaks to unshakable power and loyalty. In fact, the metaphor inspired Adolph Hitler to incorporate oak leaves in the military insignia of the Nazis and is a reason why American army majors and lieutenant colonels are decorated with gold and silver oak leaf pins. In England, many oaks hold historical prominence simply because of their locations. The famous Robin Hood Oak and the oaks surrounding Buckingham Palace are two examples.

The kilt-wearing Scottish highlander has more in common with the Vikings of Scandinavia than with the Britons in the south or the Celts in Ireland. Like the berserkers of Sweden and Norway, highland warriors often donned war paint along with their ceremonial tartans before going into battle. A hardy race of fishermen and sheep herders, the Scots symbolize stringent economy born from a life in an unyielding environment.

The image of a golfer wearing knickers and tam-o-shanter and braving the highland winds may have little to do visually with Tiger Woods and the U.S. Open. However, golf is Scotland's national sport. And the figure of a classic golfer represents the elite sporting life. Those who can afford to play golf have achieved a high enough level of importance in the working world to afford the trappings of golf good clubs, membership at a local golf course, and friendship with other successful people.

⚘ Plants

Often associated with the type of love that transcends death, the red rose is said to have been born from the blood of Adonis, the lover of the goddess Aphrodite. The red rose signified resurrection, which is why ancient Romans celebrated Rosalia between mid-May and mid-July in honor of the dead. The white rose is a well-known metaphor for death or for remembrance as was seen in the commemorations for the late Princess Diana.

In British heraldry, however, white roses are emblems of the house of York, while red roses are the insignia of the house of Lancaster. The red and white Tudor rose is a combination of the two heraldic flowers—the outcome of the War of the Roses.

The national symbol of Ireland, the shamrock, is closely associated with the nation's patron saint, Patrick, who used the three-leafed plant as a natural example of the doctrine of the Trinity (God the Father, Son, and Holy Spirit) in an attempt to convert the sun-worshipping Celts to Catholicism.

The thistle—Scotland's national emblem—symbolized the reversal of evil omens in ancient European cultures before it simply became a figure of pastoral beauty. During the Victorian era, a bouquet of thistles also communicated to its recipient that "the poetry of life sweeps over you, leaving no trace." But in China, the same bouquet signifies loyalty and longevity, because the blossoms don't lose shape with age.

☐ Shapes

The round-bowled ceramic teapot known as the "Brown Betty" is a familiar symbol of British tradition, as is the wood-handled black umbrella. One symbolizes the national obsession with ritual and propriety associated with daily routine, such as the making and consumption of tea. The trusty British "brolly" not only represents protection from inclement weather, it is also an emblem of the daily ritual performed by the British white-collar worker who religiously dresses in his conservative black or midnight blue suits, dons his derby, tucks his newspaper and briefcase under his arm, and picks up his umbrella from its appointed place—the umbrella stand beside the front door.

MISCOMMUNICATIONS

Although the United States and Great Britain reputedly share the same language, some words do not have precisely the same connotation from one side of the Big Pond (the Atlantic Ocean) to the other. As playwright George Bernard Shaw put it, they are "separated by a common language." For example, when an American comments that an object or a person is "quite pretty" or "very handsome," he or she is making a complimentary statement. These same phrases, however, are insults in Britain, where the addition of a qualifying adjective is meant to diminish or reverse a word's meaning.

An American may describe a person as being a brilliant artist or that a color palette consist of brilliant hues. In these instances, brilliant implies that the person is ingenious—a shining example—and that the colors used are full of life. But in England the word "brilliant" can be both a sarcastic comment about a person's lack of intelligence or a positive acknowledgment, depending on the speaker's gestures, facial expression, and vocal intonations.

The fox hunt, the chase of a fox by men on horseback and a pack of specially bred foxhounds, originated in England sometime between the 15th and 17th centuries depending upon the historical source. It is a sport that is rich in traditional and symbols, notably the attire worn by the participants, including a bright red jacket with black trim and white jodhpurs. These images, taken by photographer Nichole Sloan and featured in her self-promotion created by Rigsby Design, spotlight the Iroquois Hunt, one of the oldest and most well known hunts in the United States. Though distinctly American, this foxhunt incorporates all the vivid imagery symbolic of the traditional English hunt. The primary difference between the sports is that the goal of American foxhunts is the chase of the fox, not the kill.

PROJECT NICHOLE SLOAN PHOTOGRAPHY PROMOTION
DESIGN FIRM RIGSBY DESIGN
ART DIRECTOR LANA RIGSBY
DESIGNERS/
COPYWRITERS LANA RIGSBY, PAMELA ZUCCKER
PHOTOGRAPHER NICHOLE SLOAN
CLIENT NICHOLE SLOAN PHOTOGRAPHY

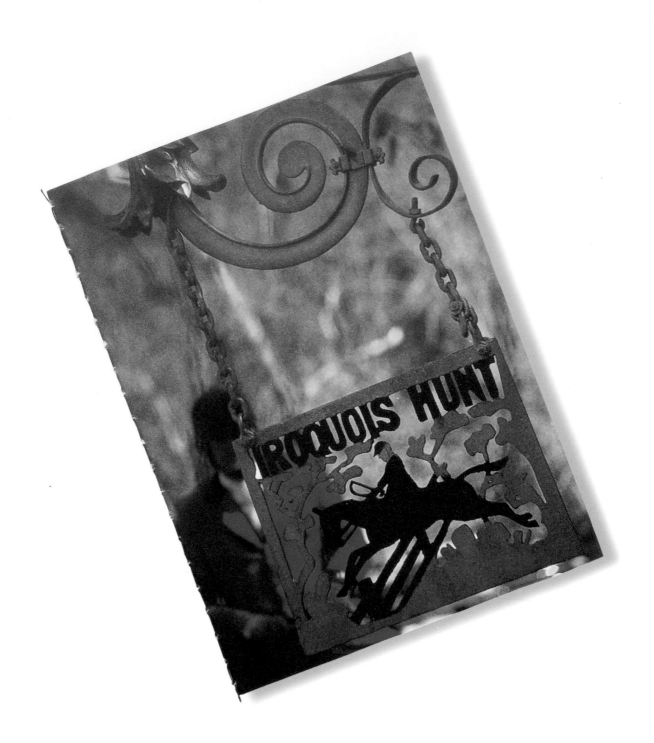

Designer Don Weller created this logo for an embroidery company, which focuses on two contrasting elements: a winged lion and a threaded needle. Strength and a high position in the marketplace are the obvious messages conveyed with this symbol. Weller expanded on this thought by creatively packaging the concept as a contemporary version of a very early logo form, a coat-of-arms.

PROJECT JM EMBROIDERY LOGO
DESIGNER DON WELLER
DESIGN FIRM THE WELLER INSTITUTE FOR
 THE CURE OF DESIGN

The winged horse, Pegasus, was said to have been born from the beheaded torso of the gorgon Medusa. A symbol of poetic inspiration in modern Greece, and seemingly overused as a symbol of rapid communication in the West, Pegasus was said to have opened the Hippocrene spring at the home of the Muses, Mount Helicon, by stomping the ground with his hooves. A symbol of swiftness and speed, Pegasus implies ease of application in this package design, which was created by Ireland's Design Factory.

PROJECT PEGASUS CONDOM PACKAGING
DESIGN FIRM DESIGN FACTORY
ART DIRECTORS AMANDA BRADY, STEPHEN KAVANAGH
DESIGNER/
ILLUSTRATOR AMANDA BRADY
CLIENT PEGASUS LTD.

The Horse

Universal Symbol
NOBILITY AND POWER

The horse is not an indigenous animal in the Americas; it was introduced during the fifteenth and sixteenth centuries by the Spaniards, who had mastered this highly intelligent creature many centuries earlier. A symbol of power and vitality, the horse was a primary subject of the paleolithic cave paintings in France and Spain. Because few cultures developed a tradition of taming the horse until thousands of years later, it was sometimes associated with the dead and the afterlife in northern and eastern European tribes. But because of its agility and speed, Greeks and Romans believed that the horse symbolized the sun. Legends of sun gods, such as Apollo and the Hindu god Mithras, often portray them riding the skies in horse-drawn chariots.

There is also an eastern European myth about horses locating the undead hiding in cemeteries by stamping and pawing at their graves.

In Christian iconography, the image of a white horse is associated with the concept of Christ as he triumphs over evil. Horses were also associated with many saints, including St. George, St. Martin, and St. Eustace.

Modern-day psychologists have paired the horse with nobility and the intellect. In dream interpretation, a horse and its rider are often interpreted as the integration of id and ego. European fairy tales narrate the stories of horses who speak with human voices, advising their riders and possessing magical powers. Horse skulls were often placed in the gables of houses as talismans against misfortune. Pre-Christian Germans sacrificed horses and ate their flesh as part of a common religious ceremony. When Pope Gregory III heard of this practice in 732 A.D., he banned the consumption of horse meat by Christians—a taboo that still exists today.

However, cultures in the Americas seem to have adopted the belief that the horse also symbolizes freedom. One famous image of a defeated Plains Indian warrior and his horse depicts both rider and animal with their heads bowed down, suggesting the loss of their battle for freedom. The Ford Company's sports car, the Mustang, was named after the wild horses that once roamed the plains and deserts of the western United States, descendants of Spanish steeds that had been set free to roam the New World.

A symbol of nobility, the horse's head that appears on this George Killian logo implies its high standing in the brewing community. Killian's history dates back to 1864 when George Killian began the brewery in Enniscorthy, Ireland, hence the use of imagery associated with the pubs that dot the local landscape throughout the United Kingdom. Today, many of these brews are produced in the United States, but the imagery on the product packaging retains the old world charm of the company's origins.

PROJECT	GEORGE KILLIAN WILDE HONEY PACKAGING
DESIGN FIRM	CMA
DESIGNER	ROGER HUYSSEN

People either love Las Vegas or they hate it. Either way, this love/hate relationship is not limited to Americans. Today, images of cowboys, showgirls, and the King—Elvis Presley (and Elvis impersonators) are synonymous with Las Vegas glitz. Its easy to see why this collection of images was chosen to play up the fun aspect of this mailer, giving recipients a chance to win a trip to Vegas. HGV Design Consultants, a London-based firm, created the design for a British client; the contest was promoted throughout the United Kingdom. As a pop culture icon, Elvis Presley's appeal is global. While he isn't on a par with Princess Diana as a symbol in Great Britain, he is as recognized as a symbol of Las Vegas and rock and roll throughout the world as Diana symbolizes the British Crown, beauty, fashion, and humanitarian causes around the globe.

PROJECT LAS VEGAS COMPETITION MAILER
DESIGN FIRM HGV DESIGN CONSULTANTS
ART DIRECTORS JIM SUTHERLAND, PIERRE VERMEIR
DESIGNER MARK WHEATCROFT
PHOTOGRAPHER EDWARD WEBB
COPYWRITER RICHARD MORRIS
CLIENT TELEGRAPH COLOUR LIBRARY

France

Fashion, style, art, poetry, and romance—the imagery of France, c'est magnifique!

The white panel in the tricolor French flag represents the House of Bourbon, hereditary ruler of that nation. While the red and blue panels are reputedly the symbolic colors of Paris, together, it is said the colors represent liberty, equality, and fraternity.

France is not simply renowned for its style and taste. The French people and their surroundings are also associated with young love and cool-headed sexuality. Paris evokes a world of art, poetry, and fashion. The image of young poets and painters waxing philosophic over coffee and liqueurs in cafés was valid long before American authors such as Hemingway and Fitzgerald wrote of its ironies and excesses. And it lived on after World War II even though the familiar bicycles were replaced by motorcycles called café racers (page 000) and talk of anarchy and revolution turned into discussions of existentialism.

Since the days of Louis XIV, French men and women have been touted as fashion forerunners, sporting outrageous costumes that later become fashion classics. Modern-day names such as Dior, Saint-Laurent, Givenchy, and Chanel have become virtually synonymous with the notion of haute couture.

Animals

The national bird of France is the cock or rooster—le coq de France. Associated with both the sun and the Sun King, Louis XVI, the cock is said to ward off the demons of the night by crowing to announce the dawn. The cock's comb was believed to be a powerful talisman against nightmares. Three crows of the cock—a reference to the apostle Peter's three denials of Christ before the cock crowed—were a powerful warning against arrogance. By the nineteenth century, the cock was considered an emblem of readiness and territoriality as well as a strong symbol of masculinity.

Plants

Although the highly stylized fleur de lis most closely resembles an iris, this variation of the lily has represented the French nation since the reign of Louis XI and the house of Bourbon. In European cultures, the pale flower has been a symbol not only of purity, but of death.

Shapes

Champagne is in French tradition a symbol of the *joie de vivre* (joy of living) embraced by young and old alike. The champagne bottle and fluted glasses together suggest merriment and romance. An open bottle of champagne accompanied by balloons and streamers signifies the celebration of the New Year. Champagne, by definition, only comes from France, specifically from the Champagne region.

Built by Gustav Eiffel for the World Exhibition of 1889 and the centennial of the French Revolution, the Eiffel Tower in Paris is perhaps France's most famous icon.

No other symbol exists that says Paris as strongly and as succinctly as the Eiffel Tower. Greteman Group designers used the familiar image of the famous structure on the cover and again inside the brochure in a striking die-cut to invite Rockwell Collins' client to visit the company's booth at the Paris Air Show. The symbol speaks for Paris and all of France, never so eloquently than in the magnificent fireworks show staged at the monument to usher in the year 2000 as the world looked on.

PROJECT	PARIS AIR SHOW 1999 INVITATION
DESIGN FIRM	GRETEMAN GROUP
ART DIRECTORS	SONIA GRETEMAN, JAMES STRANGE
DESIGNER	JAMES STRANGE
COPYWRITER	RALEIGH DRENNON
CLIENT	ROCKWELL COLLINS

Fabrice Praeger's identity for the Musée National du Moyen Age (National Museum of the Middle Ages) was chosen over the works of five other studios and it is easy to see why. The logo treatment, a stylized version of a castle turret, is flexible—Praeger modifies it for use on business cards, banners, and when he stretches the logo to increase its height, it can be used on a long page to announce exhibitions. At the outset Praeger wanted an image that would appeal to children and adults, while representing the Middle Ages. "I noticed that the most obvious symbols that people recognize from the Middle Ages are castles and their battlements," said Praeger. Stone castles and protective moats are architectural icons of the chivalry and notability that were virtues in medieval Europe and examples of these ancient castles are particularly prevalent throughout France.

In addition to the symbolism inherent in the castle tower, Praeger added the moon to symbolize the mystery of the Middle Ages and poetry. The initial mark included a gold moon, but this was changed in the final version to white. Interestingly, the client also asked Praeger to reverse the original direction of the moon from the crescent shape pointing to the right to avoid any Islamic overtones. "It's a good and simple symbol for French culture. It's very easy to remember," Praeger said. "It's something that we, French people, recognize since we [were] pupils studying history at school."

PROJECT MUSÉE NATIONAL DU MOYEN AGE IDENTITY
DESIGN FIRM FABRICE PRAEGER
ART DIRECTOR/
DESIGNER FABRICE PRAEGER
CLIENT MUSÉE NATIONAL DU MOYEN AGE

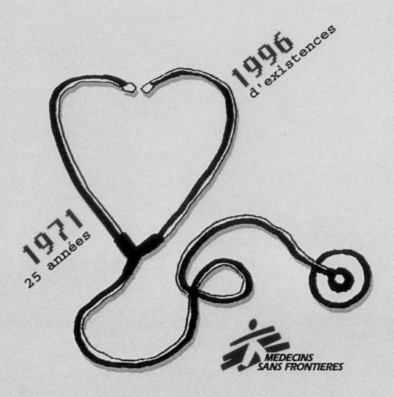

When Medécins sans Frontières (Doctors without Borders) asked Fabrice Praeger to develop a logo for the organization's 25th anniversary, Praeger took on the job provided he could avoid using images traditionally associated with anniversary year promotions. The designer avoided using a caduceus, the traditional medical symbol, or a logo with candles. Instead, he used a stethoscope, the earpieces of which naturally form the shape of a heart. "I told them...unfortunately, after twenty-five years, if you are still here that's because there is still (and always will be) misery on Earth," said Praeger. "I decided...to create a sign with a lot of love inside. That's why I created this stethoscope, which also looks like a heart."

PROJECT MÉDECINS SANS FRONTIERES 25TH
 ANNIVERSARY LOGO
DESIGN FIRM FABRICE PRAEGER
ART DIRECTOR/
DESIGNER/
ILLUSTRATOR/
PHOTOGRAPHER FABRICE PRAEGER
CLIENT MÉDECINS SANS FRONTIERES

 The C.I.D.I.L, a milk company, organized a competition to develop a new logo and Fabrice Praeger submitted this winning entry. Praeger uses the traditional image of a cow, but under Praeger's hand, the cow's black spots are drawn as maps of France—a subtle, almost subliminal, treatment for a national symbol.

PROJECT	**C.I.D.I.L LOGO**
DESIGN FIRM	**FABRICE PRAEGER**
ART DIRECTOR/	
DESIGNER/	
ILLUSTRATOR	**FABRICE PRAEGER**
CLIENT	**C.I.D.I.L (CENTRE INTERPROFESSIONNEL DE DOCUMENTATION ET D'INFORMATION LAITIÈRE)**

 The Centre George Pompidou asked Fabrice Praeger to create a special product to commemorate July 14, France's Bastille Day. This project was one of two proposed by the designer. The fashion shoot focused upon a young woman wearing a béret—the traditional French hat, readily associated with all things French. To finish it off, Praeger attached a little French flag to the stalk on the top of the béret.

PROJECT LA BOUTIQUE DU CENTRE
 GEORGE POMPIDOU JULY 14 PRODUCT
DESIGN FIRM FABRICE PRAEGER
ART DIRECTOR/
FASHION DESIGNER/
PHOTOGRAPHER FABRICE PRAEGER
CLIENT LA BOUTIQUE DU CENTRE GEORGE POMIPDOU

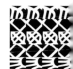

84 · 85

These two posters are part of a series of ten, created annually to promote a traveling exhibition. The butterfly is symbolic of a messenger, announcing the exhibition to each of ten different cities in France. So recognizable is the butterfly as a symbol of a messenger that designers have used the symbol for ten years to promote the events. The years vary, so do the cities and the topics, but the butterfly remains the one constant throughout the poster series.

PROJECT **10 ANS, 10 VILLES (10 YEARS, 10 CITIES) POSTER SERIES**
DESIGN FIRM **MURIEL PARIS ET ALEX SINGER**
ART DIRECTORS/
DESIGNERS **MURIEL PARIS ET ALEX SINGER**
CLIENT **FESTIVAL D'AFFICHES DE CHAUMONT**

Germany

German robustness is often symbolized by images of alpine skiers and climbers.

According to some accounts, the tri-colored German flag had its origins in the colors of the Holy Roman Empire's coat-of-arms.

Germany is associated with hard work and the rewards of health and affluence. The refined, proud, and industrious nature of the German people is all but tempered by their love of sports and the outdoors. And like its Scandinavian neighbors, health is another concept that is symbolized by common images of German mountain-climbers and skiers.

But there is another side to the German persona, represented most famously by the Rheinland castles and by the ancient Norse/Teutonic legend of the Valkyries. Riding through the clouds on horseback, these seven maidens transported brave warriors who died in battle while valiantly defending the honor of their families and their land. Named Valhalla, this warrior heaven—a great castle hall enclosed by a set of massive wooden doors—has become an image of the ultimate reward for valor. Richard Wagner's vision of the Valkyrie Brunhilde in his tragic operatic masterpiece, *Die Niebelungenlied*, has become a symbol for the word robust. She is often depicted as a strong, burly beauty dressed in a flowing gown and grasping a spear, with long blonde braids streaming from a horned warrior's helmet.

Animals

For many modern-day westerners, the pig is a symbol of uncleanliness. However, in Scandinavia and Germany the pig's reputation is elevated. Originating with an old custom of awarding a pig as the consolation prize to the last-place contestant in a competition, the pig has become a German symbol of good fortune, and is incorporated into the festivities surrounding New Year's Day. The phrase *schwein haben* (having a pig) is an idiom meaning to be fortunate. Other regions regard the pig as a sign of fertility, prosperity, and wisdom. The Norse goddess Freya was called the Sow, and the wise Celtic goddess, Cerwidwen, was frequently depicted as a swine. In Chinese astrology, and thus in Chinese culture in general, the sign of the pig is an indication of masculine strength. The boar is also considered to be a symbol of manliness in European countries, including the Celtic countries of the British Isles and Germany, where it additionally signifies naked aggression in battle and valiant courage. In fact, many German place and personal names contain the word *eber* (boar).

People

Oktoberfest revelers signify thanksgiving and rejoicing for a bountiful harvest. Usually depicted in traditional Bavarian costume—lederhosen, vests, and feathered caps for men, elaborately embroidered dirndls and blouses for women—the image of Oktoberfest revelers raising their beer steins in a toast has become synonymous with the German spirit of merriment and good will. The beer stein itself, with beer foam spilling out from under its open lid, is another traditional symbol of Oktoberfest celebrations.

FAHRSCHULE
HÄSLER

Germany's Autobahn and reputation for manufacturing precision-engineered performance automobiles are part of the country's symbolic heritage. In the case of this German driving school, designer Bernd Luz incorporated four elements of driving into the firm's logo: the steering wheel, speedometer, tire, and points. In this logo, the red point stands for "permission to drive."

PROJECT	FAHRSCHULE HÄSSLER CORPORATE IDENTITY
DESIGN FIRM	REVOLUZION STUDIO FÜR DESIGN
ART DIRECTOR/	
DESIGNER	BERND LUZ
CLIENT	FAHRSCHULE HÄSSLER

When you are located in the middle of Europe—amid countries speaking their native languages—as Germany is, a company name may not resonate with its target market, but images of its products might. Here, the designers integrated various symbols representing hydraulic component parts, Assfalg's products, into the letterhead, business card, and envelope to differentiate the company and communicate succinctly to its market, regardless of the language spoken.

PROJECT	ASSFALG IDENTITY SYSTEM
DESIGN FIRM	REVOLUZION STUDIO FÜR DESIGN
ART DIRECTOR/	
DESIGNER	BERND LUZ
CLIENT	ASSFALG

THE SWAN

The swan is a common symbol of feminine grace; according to German superstition, virgins were said to be transformed into prophetic swan maidens. The legendary Germanic swan knight, Lohengrin, was depicted as a peace-loving image of royalty. The Greco-Roman goddesses Aphrodite and Diana were often portrayed with swans at their sides. A dominant figure in many European legends, the swan generally signifies purity and nobility. Swans were said to be present at Apollo's birth, carrying him across the sky and receiving the gift of prophecy as their reward. The story is the source of the phrase, swan song. The bird is said to tell of its own impending death and bemoans its own demise by crying out.

However, during the Middle Ages, swans were symbolic of hypocrisy. Their pure white feathers were thought to conceal darkened flesh. But it was not the first time this metaphor was formed. In Greek myth, the god Zeus transformed himself into a graceful, seemingly innocent swan when he stalked and impregnated the unsuspecting maiden, Leda.

In European cultures, geese have long been associated with women and the household. Long before Mother Goose was invented, the ancient Greeks considered the goose as a sacrificial animal and an inexpensive source of warmth and food. In ancient Rome it was prized for its liver—a culinary delicacy; in modern France the liver of a fattened goose— paté de fois gras—still commands a high price. The people of Gaul (now France and Spain) believed that goose meat was an aphrodisiac. And the Norse told tales similar to the Siberian story of the priest who felt that he was carried up into the air by flocks of migrating wild geese while in a trance. In China, the goose is considered to be the Bird of Heaven, symbolizing creativity, love, constancy, truth, and inspiration.

But the most familiar symbolic references about geese have to do with their alleged talkativeness. This stems from a Christian legend. When St. Martin discovered that he was to be made a bishop, he modestly refused and hid in the barn with geese. The birds were so upset by his presence that they wouldn't stop squawking.

To create a logo and CD packaging for Christ's Sake, a Christian hard rock band, designer Marçel Robbers used a Roman typeface and overlapped a *C* and *S*, the initials of the band's name. When a cross is nested between the two letters, the result is a logo rich in Christian symbology. Likewise, when the band's name is spelled out, the cross becomes the letter *t* in Christ.

PROJECT CHRIST'S SAKE CD *CONVICTS OF CONFESSION*
DESIGN FIRM BRAUE DESIGN
ART DIRECTOR/
DESIGNER/
ILLUSTRATOR MARÇEL ROBBERS
CLIENT DATAFILE MUSIC

■ Braue Design created this logo for a German travel agency selling Mediterranean cruises. The firm was charged with creating a logo that would be as effective when reproduced in color or black-and-white. As a result, the designer expertly integrated symbols and colors for optimum effect and flexibility. The blue space stands for the open sky on the sea. The yellow steering wheel works as a symbol of an ocean cruise and represents the Mediterranean sunshine. Finally, the wave at the bottom of the logo symbolizes the water.

PROJECT LLOYD TOURISTIK LOGO
DESIGN FIRM BRAUE DESIGN
ART DIRECTOR/
DESIGNER/
ILLUSTRATOR MARÇEL ROBBERS
CLIENT LLOYD TOURISTIK

Massive Joy was an all-girl pop music group from Berlin, Germany, in need of a logo. By combining the letters *M* and *J*, designers built an abstract rendering of Berlin's trademark monument, the Brandenburger Tor, which symbolizes the band's initials as well as its place of origin. The flame that dots the *J* symbolizes the spirit and passion the girls put into their music and live performances. Finally, the three columns that result from the combination of the *M* and *J* stand for the three band members.

PROJECT	MASSIVE JOY LOGO
DESIGN FIRM	BRAUE DESIGN
ART DIRECTOR/	
DESIGNER/	
ILLUSTRATOR	KAI BRAUE
CLIENT	MASSIVE JOY

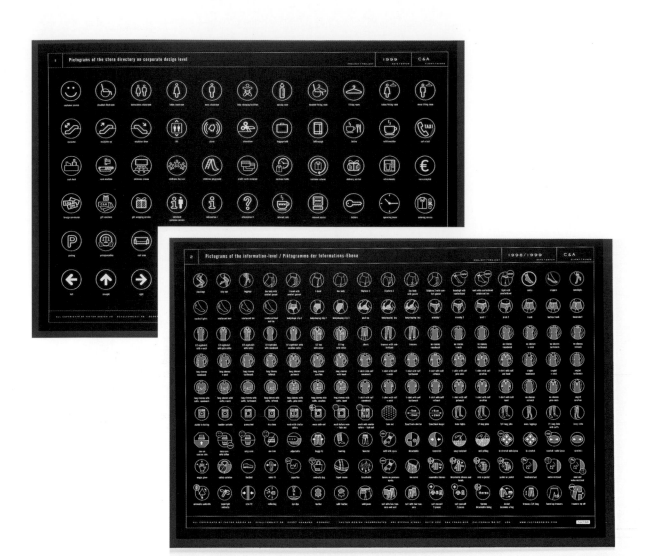

Factor Design created these icons for use in retail directories and as directional signage in stores throughout Europe. While the symbols were produced primarily for use on ceiling signs inside stores, designers created them with an eye toward use on ancillary material including posters, brochures, and packaging. The simplicity of these graphics—designating everything from gender-specific rooms to clothing care instructions—transcend language barriers, a common communication problem in Europe, and are as easily recognizable and understandable across the pond.

PROJECT STORE DIRECTORY ICONS
DESIGN FIRM FACTOR DESIGN GMBH
ART DIRECTORS OLAF STEIN
DESIGNERS FLORIAN SCHOFFRO, MARKUS BLANKENBURG,
 ANNE FISCHER, TANJA BÖMERS, TANJA SCHMIDT
CLIENT C & A

☐ Ultima Ratio, an international financial consulting company based in Germany, was in need of a logo that would translate globally when it approached Braue Design for a new identity after a merger. "This financial consulting company shows their clients a safe way out of a maze of potentially bad business decisions," said Kai Braue, explaining why a maze was the logical symbol for the company's new mark. The maze graphic is simple, yet fresh, and one that is easily understood around the world.

PROJECT	ULTIMA RATIO LOGO AND MARBLE FLOOR
DESIGN	
DESIGN FIRM	BRAUE DESIGN
ART DIRECTOR/	
DESIGNER	KAI BRAUE
CLIENT	ULTIMA RATIO

Scandinavia

Scandinavian symbols, like the Viking, celebrate the hearty, healthy outdoor life.

Comprised of Denmark, Sweden, Norway, Iceland, and Finland, Scandinavia symbolizes the hearty outdoor life. From its Viking ancestors, its present-day arctic nomads known as the Sami, and its urban cross-country ski enthusiasts, Scandinavians have had a love affair with nature for centuries.

A healthy diet and plenty of exercise coupled with massage and sauna are part of most standard health-spa prescriptions. But these activities are also part of daily routine in the European "Land of the Midnight Sun." Scandinavian blonde beauties, such as Greta Garbo, Ingrid Bergman, and Liv Ullman, have become symbols of this healthy outlook produced by an otherwise harsh arctic existence.

Animals

Reindeer are slightly smaller relatives of the large, elk-like caribou that roam North America and Greenland. Herded by the Sami of Scandinavia and the Nenets and Chukchi of Siberia, reindeer have been domesticated in these northern latitudes for nearly twenty centuries. Unlike their wild caribou cousins, reindeer have been kept as pets and bred for food, shelter, and transportation. The indigenous people of Scandinavia and their Norse ancestors have long associated the reindeer with rebirth, rejuvenation, and time. The reindeer stag's antlers were likened to the rays of the sun. One myth tells of four stags that grazed on Yggdrasill, the world-tree, eating the buds (hours), blossoms (days), branches (seasons), and the trunk (years).

Trolls are symbolize magical powers in Scandinavian folklore. These half-man, half-beast creatures purportedly lived in castles and haunted the surrounding area after dark. If they were exposed to sunlight, they burst into flames or turned into stone.

People

In the same manner that redheads are a symbol of the volatile Irish temperament, blondes signify the allegedly imperturbable Scandinavian temperament. In many parts of the world, famous Scandinavian blondes like the elusive Greta Garbo epitomize this concept.

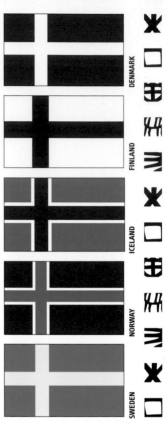

DENMARK

FINLAND

ICELAND

NORWAY

SWEDEN

The cross represents each Scandinavian nation's conversion to Evangelical Lutheranism. But their similar design also alludes to occasionally muted borders. Sweden, Norway, and Iceland were all under Danish rule at one point. Finland was under Swedish rule before joining forces with Russia.

MISCOMMUNICATIONS

Swedish vacuum cleaner manufacturer, Electrolux, had to rework its highly successful marketing program when it launched its American campaign. Its motto, "Nothing sucks like an Electrolux," somehow didn't have the same meaning in the United States.

□ *Shapes*

Snowflakes are a common motif in Scandinavian arts, crafts, and apparel. These unique geometrically shaped ice crystals are symbolic of the cold, of winter, and of snow-related sports such as alpine and Nordic skiing, snowboarding, sledding, and ice skating. Though in other parts of the world winter is often equated with death, a time when life lies dormant, the snowflake motif captures the vital beauty that Scandinavians find in this season when the land is blanketed in sparkling white crystals.

Skis and skiing are also familiar symbols of winter and Scandinavia. Although cross-country (Nordic) skiing is a Scandinavian invention, alpine (downhill) skiing is also a favorite pastime in this subarctic region.

In Egyptian lore, the hawk's noble calling bore overtones of death. The god of the dead, Seker, was depicted as a mummified hawk. During medieval times, peasants saw hawks as scavengers who swooped down on open markets to snap up scraps of meat. This image was often used to describe a human being who thought only of his or her stomach.

Equated with the sun (page 111) in many cultures because of its apparent ability to outstare the sun's light, the hawk and the falcon are frequently depicted in Christian iconography accompanying St. Hubert, the patron saint of hunters. Today, the hawk generally symbolizes a person who favors war over peace—the opposite of the dove. If they are not portrayed in the classic warlike poses—talons forward, swooping on prey, or clutching arrows—hawks can also be interpreted in terms of swiftness, decisiveness, and fitness for survival.

A familiar motif used throughout Scandinavia, the reindeer evokes rebirth and the passage of time. But it also heralds Christmas time in many western nations because of its associations with the legend of Santa Claus. Malik Design took advantage of this link is the solution for Merry Moments (above right).

Similarly, Lambert Design employed the reindeer's Christmas association for the tag used on the packaging for Reindeer Feed chocolate candies (above left).

PROJECT **MERRY MOMENTS HOLIDAY IDENTITY**
DESIGN FIRM **MALIK DESIGN**
ART DIRECTOR/
DESIGNER/
ILLUSTRATOR **DONNA MALIK**
CLIENT **FRANCO MANUFACTURING**

PROJECT **REINDEER FEED**
DESIGN FIRM **LAMBERT DESIGN**
CLIENT **REINDEER FEED**

THE FALCON AND THE HAWK: THE SPORT OF KINGS

Falconry is often referred to as the sport of kings. The swift, keen-sighted falcon has possessed noble associations since the days of the Egyptian pharaohs. The peregrine falcon, which became a symbol of royalty, could reputedly paralyze other birds with its stare in the same manner the pharaoh himself could turn his enemies into stone with his countenance. The god of the sky, Horus, was depicted as a hawk, the highest-flying bird on the desert landscape. In Norse legend, the god Odin transformed himself into a falcon so he could fly across the sky. And the cunning Loki, the Norse god of mischief, metamorphosed into a rapacious hawk.

96 · 97

A symbol for eternity, the noose of Isis knot, a symbol with African roots, was used as the central focus of this design for an identity system in Scandinavia.

PROJECT	**FINERGY IDENTITY SYSTEM**
DESIGN FIRM	**INCOGNITO DESIGN OY**
ART DIRECTOR/	
ILLUSTRATOR	**KEIJO VUORIEN**
DESIGNER	**J.P. SILTANEN**
CLIENT	**ENERGIA-ALAN KESKUSLIITTO**

Fortum

When two energy-producing companies merged, the result was this logo that combined the corporate colors from each individual company. Coincidentally, the colors worked together well—creating a design that not only represents two separate entities forming to become one, but depicts the global nature of the newly created company—the green earth surrounded by the blue sky. Designers highlighted the earth to give the impression of three-dimensional roundness with the lightest point at the one o'clock position to depict a company that is looking toward the future.

PROJECT FORTUM COMPANY LOGO
DESIGN FIRM INCOGNITO DESIGN OY
ART DIRECTOR/
DESIGNER KEIJO VUORINEN
ILLUSTRATOR VÄINÖ TEITTINEN
COPYWRITER EIJA HARJU-JEANTY
CLIENT IVO

Netherlands

Tulips, windmills, and wooden shoes are national symbols of The Netherlands culture.

The red, white, and blue flag of The Netherlands predates the French tricolor flag of the same colors. However, the flag of the Netherlands originally had an orange band across the top, which represented loyalty to William of Orange.

At one time, much of The Netherlands, which means low lands, was and would still be underwater if not for a series of dikes that have come to symbolize the region. The area is also known for its neutrality and is home to The Hague, the seat of government that is used as a venue to settle many international disputes.

⊕ Plants

Tulips are almost synonymous with Dutch culture and these red, pink, yellow, and white flowers and bulbs are a chief export. According to The Netherlands Flowerbulb Information Center, Turkish gardeners were responsible for introducing tulips to Europe after they hybridized the native tulips of the eastern Mediterranean shores.

□ Shapes

Windmills were used in the Middle Ages to pump the water out of low-lying areas. Today, they are the stuff of legend, rich in history and romance; they are also associated with dreams and are inextricably linked to the eternally optimistic fictional character, Don Quixote de la Mancha.

Wooden shoes, which date to the mid-1300s, are another familiar Dutch symbol. While they are primarily associated with traditional Dutch costume, they are also used widely today by gardeners, fisherman, and other industrial workers for the comfort, warmth, and protection they provide.

Likewise, The Netherlands is known for the windmills that dot the landscape. Used originally to pump water out of low-lying areas, today, windmills are popular tourist locations and images of windmills are readily associated with the Dutch.

♟ People

Hans Brinker or *The Silver Skates* by Mary Mapes Dodge tells the story of a boy's journey from Amsterdam to The Hague on ice skates. The story is read by children the world-over.

Also symbolic to Dutch culture are its painters: Rembrandt van Rijn, Vincent van Gogh, Johannes Vermeer, Jan Steen, and Piet Mondriaan.

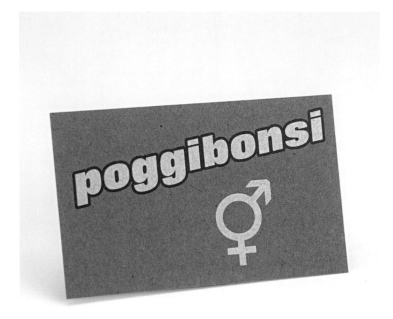

 Designer Erwin Zinger combined the traditional symbols that designate the male and female sexes to create one symbol that references both—a circle with an arrow extending from the one o'clock position and a cross emanating downwards from the six o'clock position. He uses it here as the key element in a logo for Poggibonsi, a fashion retailer that sells business casual clothing for men and women. "I took both the man and woman symbols and united them because everybody knows what these symbols stand for. You just can't communicate better in any other way," said Zinger. The logo sells consumers on the store. Once inside, the store itself assumes the sales role by showing off the clothes.

PROJECT POGGIBONSI RETAIL IDENTITY MATERIALS
DESIGN FIRM ERWIN ZINGER GRAPHIC DESIGN
ART DIRECTOR/
DESIGNER ERWIN ZINGER
CLIENT POGGIBONSI

poggibonsi

Stichting GAO is an organization that provides people with the information and funding they need to ensure

Spain and Portugal

Spain and Portugal possess a dual symbolic nature—that of Christian devotion versus raw emotion.

Spain's flag, as well as Portugal's, prominently feature heraldic coats-of-arms at their centers.

Spain possesses a dual symbolic nature. On the one side stands the proud, brave matador who stands before the raging bull—human beings defying nature's unbridled power. This kind of passion has inspired Spanish people to fight impossible odds, not just against nature, but also against other human beings—from the fifteenth-century Moors to the nineteenth-century French under Napoleon, and of course to their own compatriots in the Spanish Civil War. But this deeply rooted passion also gave birth to one of the most famous figures in western literature—the unworldly, eternally optimistic Don Quixote de la Mancha.

The other side of this dual nature is heavily steeped Christian devotion. For all of the raw emotions portrayed by the flamenco dancers and Gypsy guitarists, there are even deeper passions attached to the Roman Catholic Church, passions transported by Jesuit and Franciscan missionaries to the Americas, Asia, and Africa.

Animals

The bull, a powerful masculine symbol at the heart of Spain's favorite spectator sport and a de facto symbol of the nation, has been worshipped in many cultures. A key element in rituals for thousands of years, it is a figure of brute force, persistence, and beastliness. Bulls have been frequently placed in head-to-head competition with humans. On the island of Crete, people demonstrated their intellectual superiority over the powerful bull by leaping over him. The bullfights performed in modern-day Spain have similar iconographic significance. Even the annual running of the bulls in Pamplona pits human beings against bulls in a ritualistic battle for survival as they race through the narrow streets.

People

Physical prowess and perfection in masculine and feminine forms are symbolically exemplified by the matador and the flamenco dancer. The matador defies nature by confronting its most powerful champion—the bull. The flamenco dancer performs impossible postures and gestures with grace and mechanical precision, challenging each muscle in the body to stretch, arch, and step beyond normal levels of expectation.

Spain's most famous figure, however, universally symbolizes the unworldly romantic, the embodiment of chivalry who does not separate dreams from reality. Don Quixote de la Mancha was created by the novelist Miguel de Cervantes Saavedra in 1605. As many Spaniards confess, there is a Don Quixote in every person. The idealistic Quixote was accompanied through his improbable adventures by his squire Sancho Panza, who symbolizes the grossly materialistic and down-to-earth nature of human beings.

A symbol of masculinity, strength, and power, the bull is the central figure of this packaging system for Paso de los Toros soft drinks.

PROJECT	PASO DE LOS TOROS SOFT DRINK PACKAGING
DESIGN FIRM	INTERBRAND AVALOS & BOURSE
ART DIRECTOR/	
DESIGNER	ARIEL MARIN
ILLUSTRATOR	HORACIO VÁZQUEZ
CLIENT	PEPSI COLA ARGENTINA

Brute force and persistence are symbolized in this logo by a furious bull.

DESIGN FIRM **TRACY SABIN GRAPHIC DESIGN**
ILLUSTRATOR **TRACY SABIN**
CLIENT **MADDOX DESIGN**

PENTACASAS

When Pentacasas, an agency that leases/rents vacation homes in the Mediterranean, needed an updated logo, Kai Braue found inspiration for the new imagery by graphically translating the business' name, Pentacasas, which has its roots in Latin. The word penta, meaning five, is represented with five open hands, "a global symbol of friendly service," said Braue. Casas, the word for houses in Latin, is shown in the logo's center. Together, the hands and the house form the shape of the sun, symbolizing the warmth of the Mediterranean, which was a required element of the new logo since it had been part of the company's original identity.

PROJECT	PENTACASAS LOGO
DESIGN FIRM	BRAUE DESIGN
ART DIRECTOR/	
DESIGNER/	
ILLUSTRATOR	KAI BRAUE
CLIENT	PENTACASAS

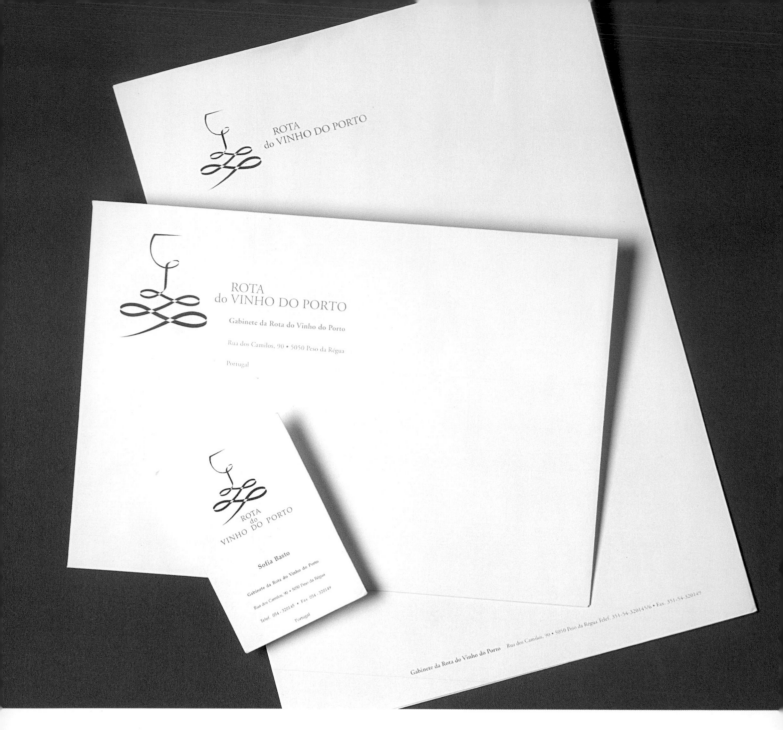

João Machado designed the business card for Portugal's office of tourism to prominently feature a wine glass, which symbolizes the country's agricultural roots and history in winemaking, particularly that of Port.

PROJECT ROTA DO VINHO DO PORTO (PORTUGUESE TOURISM) BUSINESS CARD

DESIGN FIRM JOÃO MACHADO DESIGN, LDA

ART DIRECTOR/
DESIGNER/
ILLUSTRATOR JOÃO MACHADO

CLIENT GABINETE DA ROTA DO VINHO DO PORTO

The Flag

Universal Symbol
PLEDGING ALLEGIANCE

1999 | EURO A NOVA MOEDA EUROPEIA

PORTUGAL

JOÃO MACHADO des.

95$

€ 0,47

INCM imp. 99

All flags serve as symbols representing specific groups of people, and specific sets of ideologies. Flags are rallying points, statements of belonging. The symbolism of flags is a specialized, scientific study known as vexillology. A flag signifies a nation's history—a condensed graphic honoring the citizens and particularly the armies that have pledged their allegiance to the concept, country, and group represented in the colors and shapes displayed on an otherwise inexpensive piece of cloth. A profound example of this is India's national flag, which bears a spinning wheel as its centerpiece. This device represents the country's founding father and leading inspiration, Mohandas K. Gandhi, who encouraged the people to spin their own cotton cloth in defiance of the British rule of India rather than purchase imported textiles.

Early flags, such as the Roman signa, were made out of metal and wood. Cloth flags were an Oriental invention, adopted by leaders such as Alexander the Great because it was easier for cavalrymen to carry them over long distances. Genghis Khan's flag, a black moon against a white background, struck terror throughout Eurasia as he conquered vast regions. His Chinese descendants raised an imperial yellow standard that bore a dragon and a red sun. By the ninth century A.D., flags had become a familiar form of national and familial declaration throughout Europe.

Today, there are specific protocols for raising, lowering, display, storage, and disposal of national flags. To disregard this strict code of behavior is often considered an act of treason.

☐ To commemorate the advent of the Euro, the new European currency, Portuguese designer João Machado created this postage stamp that uses the flags from the participating European countries as the backdrop. The individual flags flow into one another to make one united flag in the arresting illustration. Flags have long been time-honored symbols of nationality and patriotism. Used here, these age-old symbols are contrasted with what is sure to become a new symbol throughout Europe, the *e* of Euro.

PROJECT　　　**EURO POSTAGE STAMP**
DESIGN FIRM　**JOÃO MACHADO DESIGN, LDA**
CLIENT　　　　**CTT—PORTUGUESE POST OFFICE**

A flame can represent warmth, life's force, or danger. In this case, it is used to show that life is spontaneously combustible—particularly when hazardous materials are involved. Rad Bones, a manufacturer of sports wear for surfing enthusiasts, distributed the T-shirt to heighten awareness for its "Love Life" campaign, a promotion that educates the population about the threat to life posed by Portuguese companies that pollute the country's rivers and the ocean with hazardous materials. Because the symbol of fire is also equated with power, designers also hope that the imagery provides the power for change.

PROJECT	LOVING LIFE T-SHIRT
DESIGN FIRM	R2 DESIGN
ART DIRECTORS/	
DESIGNERS	LIZÁ DEFOSSEZ RAMALHO,
	ARTUR REBELO ALVES
CLIENT	RAD BONES

A G E N E A L

AGÊNCIA MUNICIPAL DE ENERGIA DE ALMADA

Rua Bernardo Francisco da Costa, 44
2800-029 Almada • Portugal

☐ João Machado employed a stylized illustration of the
sun to depict the work of Ageneal, a municipal agency
for energy in Portugal.

PROJECT	AGENEAL LOGO
DESIGN FIRM	JOÃO MACHADO DESIGN, LDA
ART DIRECTOR/	
DESIGNER/	
ILLUSTRATOR	JOÃO MACHADO
CLIENT	AGENEAL (CÂMARA MUNICIPAL DE ALMADA)

Global Graphics: Symbols

The Sun

Universal Symbol
THE GIVER OF LIGHT

Rising in the east and setting in the west, the sun has
generally symbolized life and humankind's victory over
darkness. Great civilizations such as those in ancient
Egypt, Mexico, Peru, and the nomadic peoples of the
North American Great Plains worshipped this star at
the center of our solar system.

The Egyptian pharaoh Amenhotep IV created a
monotheistic religion based on the worship of Amon-
Re, the Sun God. Early Christians associated the sun
with Christ, immortality, and resurrection. Ancient
Semitic and Vedic astrologers associated the sun with
the lion as symbols of masculine virtue, leadership, and
power. The Incas associated the life-giving attributes of
the sun with gold, which they believed was created by
the sun itself. They erected temples laden with gold and
dedicated them to the sun. They also mummified the
dead with gold in hopes that the sun would give them
life in the afterworld.

Symbolized in astronomy by a point encased by a cir-
cle—an image taken from the Egyptian hieroglyph for
Amon Re—the sun has been employed in religious and
decorative arts not only by Central and South
American natives but by tribal artisans of the North
American Great Plains and the Pacific Northwest. The
eagle is typically paired with this brilliant star. Many
legends narrate that the hawk or falcon are the only
animals capable of outstaring the sun's rays. However,
the people of the Arctic, Pacific Northwest, Siberia,
and Manchuria associate another bird with the sun.
The raven is said to have stolen the sun from the heav-
ens so he could warm his new creations—humans—in
the days when the earth was born.

Even modern nations employ the sun as their emblem
or as an element of an insignia. The Japanese word for
Japan—Nihon—literally means sun source. Almost
every family in that island nation claims descent from
the gods who followed Ninigi, the grandson of the sun
goddess Amaterasu Omikami. According to legend, he
descended upon the main island by a pathway created
by the clouds from eight rays of the sun. In fact, Japan
is commonly known as the Land of the Rising Sun.

Italy

Italian symbolism reflects its abundance of fine food and wine, art, and deep emotion.

This tri-colored national banner has represented the united princely states of Italy since 1946.

Since the days of the Caesars, Italy has symbolized abundance. Its bountiful harvests of fruits and vegetables are surpassed only by the rich abundance of grapes and wines. With such simple riches, it's no wonder that Italian life is also synonymous with hospitality and good will: where gathering friends and family to partake in a meal is a fine art.

Intense passion and the unrestrained expression of emotions are also concepts typified by the Italian people, who rarely repress their feelings about events or each other. In the arms of an Italian, a romantic moment swiftly changes from a simple token of affection to a steamy vow of undying love. The most famous of the Latin lovers was, of course, Cassanova. But twentieth-century Italian film stars such as Rudolph Valentino, Marcello Mastroianni, and Giancarlo Giannini have carried on this uniquely Italian iconographic legacy. There is also a history of passion in Italian art. Two artists epitomize the Renaissance: Michelangelo, with his Sistine Chapel frescoes and his divine forms—expressed in sculptures like the David—embodied the higher, spiritual element; and Leonardo DaVinci, who with his graphic studies of realism, anatomy, and flight represented the secular and even practical side of fine art.

Plants

Italy is most notably associated with grape-growing, even though vineyards are common throughout the Mediterranean region and elsewhere. Grapes and grapevines have been symbols of wine and wine-induced ecstasy ever since Greeks and Roman told tales of Dionysius/Bacchus, who introduced the fruit to human beings while leading his merry-making followers—the satyrs and maenads—through the countryside. In modern times, Bacchus himself has been melded into the figure of the beer god Gambrinus as a symbol for taverns. And grapes have been additionally incorporated in symbols of bountiful harvests, such as the cornucopia.

Shapes

A figure of free-flowing, inexhaustible bounty closely associated with Italy's abundant harvests, the cornucopia (horn of plenty) was originally depicted as a goat's horn from which fruits, vegetables, and other delicacies cascaded. According to legend, the cornucopia originally belonged to the nymph Amalthea, who nursed the infant god Zeus. The river god Achelous eventually became the guardian of Amalthea's cornucopia. Many years later, Hercules fought Achelous and accidentally broke off one of the bull-shaped god's horns. But rather than keeping the horn as his prize, he returned it to Achelous. In exchange, the defeated god gave the hero Amalthea's cornucopia. Since that day, the cornucopia has provided an unlimited bounty of gifts from the gods; bestowed upon mortals.

Roman columns are a popular symbol of Italy's past glory—its ascent to world power and its broad influence on western culture, from architecture to language. However, Roman columns are also symbols of solidity, structure, and strength. Although many of the Roman empire's buildings have fallen into ruin, many of these columns, which once supported thousands of tons of marble, have survived—enduring monuments to the ingenuity, organization, tenacity, and artistry that created the aqueducts, the vias, the coliseums, and an empire that stretched from the Near East to the British Isles. The rounded, lathed column topped by a decorative capital, though not invented by the Romans, certainly reached its stylistic peak in the hands of Caesar's artisans.

🕱 *People*

In ancient Rome, men who provided their own horses and armaments in times of war were considered a privileged class, not only on the battlefield, but in land ownership, oratory, and academic circles. As the Roman Empire grew, so did the status of these equites Romani, Roman horsemen.

But as the Roman Empire declined, these noblemen, known as knights, became a class of professional soldiers employed by kings. They did not necessarily inherit their positions because of wealth like their Roman predecessors. Rather, they earned their posts through deeds of honor and courage. And they learned their craft between the ages of fourteen and twenty-one, working as squires in the service of other knights. Being dubbed a knight by the nation's king or queen implied that the person was trusted to be virtuous and brave, willing to fight for both king and country. Eventually, knights became symbolic of honor and "chivalry," a word that derives from the French *cheval* (horse) and *chevalier* (horseman).

In European myth and legend, kings symbolize the paternal nature of national leadership and masculine power. Unlike knights, kings did not necessarily have to play active roles in battles. However, they did have to possess the same virtues of courage and honor. They were also imbued, as a matter of course, with the very real power of granting life and death. The king represents the penultimate character type, the best man there is. A prime example of this symbolic association is King Arthur of Camelot.

In many European hero myths, the king represents the final destination in the hero's journey toward enlightenment and growth—the physical embodiment of wisdom and insight, the readiness to acknowledge the completion of his personal education.

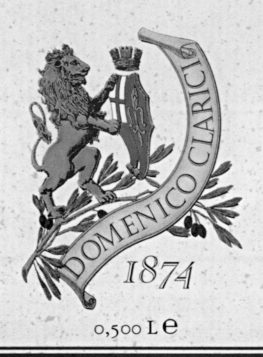

OLIO EXTRA VERGINE DI OLIVA

DOMENICO CLARICI

1874

0,500 L e

AZIENDA AGRARIA
CLARICI

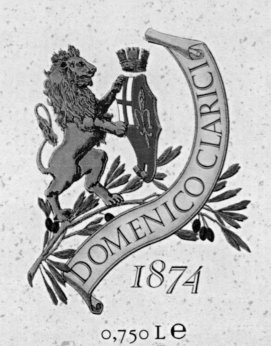

OLIO EXTRA VERGINE DI OLIVA

DOMENICO CLARICI

1874

0,750 L e

AZIENDA AGRARIA
CLARICI

Olive oil is one of Italy's primary products, so there is plenty of competition on store shelves where different brands vie for consumer attention. In this case, Studio GT & P has chosen to focus on one attribute—the manufacturer's heritage, dating back to 1874—to differentiate Clarici Extra Virgin Olive Oil from other brands. To promote Clarici's rich history in the business, a coat of arms is the perfect symbol, laid into a label that is very traditional in its design, size, and composition.

PROJECT CLARICI EXTRA VIRGIN OLIVE OIL LABEL
DESIGN FIRM STUDIO GT & P
ART DIRECTOR GIANLUIGI TOBANELLI
CLIENT AZIENDA AGRARIA CLARICI

When history isn't a sales advantage (particularly when you're in Italy and the product is olive oil), an alternate tact is to focus on the product's other attributes. Here, Studio GT & P created a contemporary design using an illustration of an olive tree to symbolize San Potente Extra Virgin Olive Oil. The illustration and the elongated design of the label combine to characterize this product as new and upscale.

PROJECT	SAN POTENTE EXTRA VIRGIN OLIVE OIL LABEL
DESIGN FIRM	STUDIO GT & P
ART DIRECTOR	GIANLUIGI TOBANELLI
CLIENT	SAN POTENTE ARGITURISMO S.A.S.

Roman columns signify strength. Roman ruins, such as the Coliseum, remind us of the strength of ancient civilizations, and as such, the image of sunrise upon once mighty columns—still standing, but in ruins—is fitting for the cover of this CD featuring musical selections from several continents that are steeped in the history of today's modern civilization. Included are tracks featuring tribal, ceremonial, wedding, fertility, and war dances of Africa and Australia, as well as music indicative of the culture and customs of India, Pakistan, and Central and South America.

PROJECT	**SOURCES OF CIVILIZATION CD**
DESIGN FIRM	**GRECO DESIGN STUDIO**
ART DIRECTOR/	
DESIGNER/	
ILLUSTRATOR	**ANDREA GRECO**
CLIENT	**PRIMROSE MUSIC**

Hands can symbolize healing and touch, as well as a variety of gestures including a military salute. Interestingly, while many gestures are identical in form, their meanings can vary among countries and cultures from those with positive connotations to others perceived to be insulting and of the rankest vulgarity. However, to the majority of people on the earth, clapping two hands together is the highest form of praise—applause for a job well done. If this gesture is done while standing, it is recognized as a request for an encore.

PROJECT	APPLAUSE CD
DESIGN FIRM	GRECO DESIGN STUDIO
ART DIRECTOR/	
DESIGNER/	
ILLUSTRATOR	ANDREA GRECO
CLIENT	PRIMROSE MUSIC LTD.

Global Graphics: Symbols

□ Starbucks Coffee Company's in-house design group created this packaging for an espresso pod, an individually wrapped espresso shot, as part of a larger Italian Heritage promotion during the month of February, which made it a likely Valentine's Day tie-in. Aside from the all-over red color palette, chosen for its association with Italy and Valentine's Day, the design is distinctive for its primary graphic—a small European car. "The photo of the car was taken on a side street of an Italian neighborhood. We felt it portrayed the romantic feel of Italy in a very subtle way," said designer and photographer Bonnie Dain. "The cobblestone street and ivy-covered wall emit the simple beauty and history of Italy."

PROJECT	STARBUCKS COFFEE COMPANY CAFFÈ VERONA POD PACKAGING
DESIGN FIRM	STARBUCKS DESIGN GROUP
ART DIRECTOR	MICHAEL CORY
DESIGNER/	
PHOTOGRAPHER	BONNIE DAIN
COPYWRITER	ALICE MEADOWS

TURISTIČKA ZAJEDNICA VARAŽDINSKE TOPLICE

118 · 119

The lion and the fish symbolize fire and water. Together, they create the perfect representation for ancient Roman thermal springs, Aqvae Iasae. The three-dimensional marble effect of the graphic and the choice of a strong typestyle are evocative of the Roman Empire.

PROJECT	AQVAE IASAE BUSINESS CARD
DESIGN FIRM	LIKOVNI STUDIO D.O.O.
ART DIRECTOR	DANKO JAKSIC
DESIGNER	TOMISLAV MRCIC
TYPE DIRECTOR	MLADEN BALOG
PRINTER	KUZMIC PRO
CLIENT	AQVAE IASAE

Greece

Greek imagery celebrates the region's history as the birthplace of academics, sport, and government.

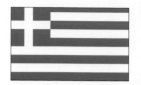

The nine stripes of the Greek flag represent the nine syllables of the nation's motto *Eleutheria a thanatos* (Freedom or death). The cross was adapted from the royal coat-of-arms.

The birthplace of democracy, Greece is also the historic cradle of academic scholarship and thus symbolizes classic philosophy. Although its golden age took place before the birth of Christ, Greek civilization is still associated with many cherished western values. It is also linked to athletics; the Olympics were first conceived here, and it was in Greece that the first modern Olympiad took place.

In today's world, there is another side to Greece. In the same way that Italy represents romance and Spain signifies passion, modern-day Greece is a symbol of soul-filled emotion. Motion picture characters such as Zorba from *Zorba the Greek* and Illya from *Never on Sunday* best exemplify the emotional Greek soul. This spirit can be summed up in the simple statement "Today is not the best day, but it's not the worst either." Dancing can cure these sorts of "blues," and the melancholic sounds of the bazouki have served as background music throughout the city of Athens, from the Pagrati hash clubs, where *rembetika* or soul music was born, to the glitzy supper clubs of the Plaka.

Animals

A symbol of the first begotten of love, the dove was adopted as the emblem of the Holy Ghost by early Christians and later as a representation of the soul itself. But the most familiar imagery of the dove combines this pure white bird with an olive branch—an image first found in the biblical story of Noah. Today, the dove bearing an olive branch is an almost universal symbol of peace and good tidings.

Plants

According to myth, the olive tree was created on the Acropolis by the goddess Athena as a sign of the competition between her and the god Poseidon for domination of Attica. Its sacred wood was used to carve statues of the gods, and a sacred grove of olive trees was planted on Mount Olympus, the home of the gods. Athena was not only the goddess of wisdom but of war. And although the olive's branches are symbols of peace when wrapped in wool or accompanied by a dove, a wreath of its leaves is a symbol of victory in battle or competition.

People

Just as the Beefeater symbolizes Great Britain, the Evzone is the figure of manly virtues for the Greeks. The uniforms of the Evzone guard are modeled after the traditional dress of soldiers from Eprius in the north of Greece. They feature a pleated kilt called a fustenella and wooden-soled hobnail shoes with pom-poms. The 400 pleats in the kilts represent the 400 years of Turkish occupation that Greece endured. This uniform is still worn today for full-dress by the men of the elite Evzone guard in Athens.

 This music CD, featuring simple orchestrations—one an instrumental entitled Venus and Volcan, featuring a flute and a guitar, while another, Aphrodite, the flute and guitar joined by soprano and baritone voices—is evocative of the imagery of Greek mythology. Consequently, the typestyle and the classic figure of mythology aptly fit the packaging design for they give hint of its musical contents.

PROJECT	*MYTHOS AND EROS* CD PACKAGING
DESIGN FIRM	
ART DIRECTOR/	
DESIGNER/ILLUSTRATOR	ANDREA GRECO
CLIENT	PRIMROSE MUSIC LTD.

Russia

Russian symbols of prosperity through communal spirit become a modern utopian ideal.

sRussia's flag proudly bears the traditional colors of the pre-Soviet Romanov empire, replacing the USSR hammer and sickle which represented more than twenty nations.

Far removed from more familiar European nations, Russia stands as a link between the Occident and the Orient, a symbol of east meeting west. Before the fall of the czarist empire, this nation was steeped in the teachings of the Byzantine Orthodox Church as well as the shamanistic rituals and superstitions handed down by the Tartar descendants of the Mongol conqueror Genghis Khan.

Despite the fall of the Soviet government in the early 1990s, images of the communist ideal linger the working and academic classes toiling side by side for the good of the people. Pictured in propaganda posters, motion pictures, murals, and works of art, the Russian image of hope and equality achieved through hard labor and communal spirit became an international type, a twentieth-century utopian ideal.

Animals

Russia's popular association with the brown bear originated with a British cartoon. Sir John Tenniel had drawn a political parody in both the February and April issues of Punch in 1878. The series depicted Great Britain as a lion, France as a cock, Germany as an eagle, Austria-Hungary as a two-headed eagle, and Russia as a brown (also known as grizzly or Kamchatka) bear. This imagery is still used throughout the world except in modern-day China, where Russia is depicted as a snowy-white polar bear.

Considered the embodiment of rough, uncouth, ill-tempered behavior in the modern western hemisphere, the bear was sacred to ancient Greeks who worshipped the goddess Artemis. Young girls would dress as bears in an initiation ceremony that took place at the goddess's temple prior to their marriage.

MISCOMMUNICATIONS

A few years ago, a Ben & Jerry's ice cream store in Moscow was informed that Soviet Premier Boris Yeltsin was going to visit the newly opened shop. The company tried to whip up a special flavor to mark the occasion. Made with berries, the American developers were going to name it Yeltsa Yeltsin, especially since the Russia term for berry is *yeltsa*. But the plan was canceled. As Ben & Jerry's public relations coordinator tells it: "They mentioned that combination of words to their Russian partners who blanched and said that particular pairing meant something like butthead. Boris didn't show up that day, so we were saved from something horrible." It wasn't the first time that happened. The company couldn't market their Mocha ice cream either, because it sounds too much like the Russian word for making water, or urinating.

✶ *People*

Images of the Russian people themselves have been commonly employed as symbols of the nation. The Cossack horsemen from the southwestern steppes were familiar figures in Czarist Russia. Bedecked in distinctive sable hats and fur-collared coats, the Cossacks signified the wildly passionate—and often melancholic—Russian nature. On the opposite side of the coin, factory workers and collective farmers—both male and female—symbolized the hard-working, proud Soviet persona. Despite the demise of the Soviet government in the late 1980s, this image is still closely associated with modern-day Russia.

⊟ *Language/Gestures*

Russians have a number of specific superstitions about body language. For example, if a Russian woman narrows her eyes, she is displaying her apprehension or discouraging potential flirtation. If a person sits with the soles of his or her feet exposed, it is taken as a sign of uncouth and rude behavior. The same holds true for the display of the soles of one's shoes. This also applies in Japan and other Asian countries.

□ *Shapes*

The distinctive onion-shaped domes that top churches and other buildings—including some homes—throughout Russia are popular symbols of the culture that existed during the reign of the czars.

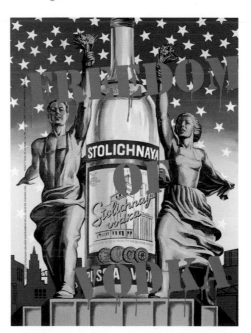

✶ The spirit of Stolichnaya, an imported Russian vodka, is conveyed by artist F. Sharikov who was commissioned by Carillon Importers to create this poster which kicked off the "Freedom of Vodka" advertising campaign. In the same way murals and statues of laborers were used to inspire the people during the Soviet regime, workers are used in this project to symbolize the personal pride that emanates from the fruits of their labors.

PROJECT STOLICHNAYA VODKA
ARTIST F. SHARIKOV
CLIENT CARILLON IMPORTERS

Nutrition Facts
Serv. Size 8 oz./(240 ml)
Servings: About 2
Calories 0

	% Daily value*
Total Fat 0g	0 %
Sodium 410mg	17 %
Total Carb 0g	0 %
Sugars 0g	
Protein 0g	

*Percent Daily Values are based on a 2,000 calorie diet.

NATURALLY CARBONATED MINERAL WATER OF CAUCASUS BOTTLED AT THE SOURCE BY ZHELEZNOVODSK MINERAL WATER COMPANY

IMPORTED FROM RUSSIA

ZHELEZNOVODSKAYA ®

SPARKLING NATURAL MINERAL WATER

HIGH MINERAL CONTENT

EXCLUSIVE DISTRIBUTOR G & V COMPANY, FRESNO, CA U.S.A. 93728 • SOME SETTLING OF MINERALS IS NATURAL AND EXPECTED

GOCT -13273-88

500 ml

16.9 fl.oz.

One of the most beautiful places on Earth, the majestic Mount Elbrus (the highest peak in Europe), is home to the world's most famous mineral waters.

Since the discovery of these wonderful waters in 1810, Europeans have flocked to the Caucasian Mineral Waters Spa to experience the waters for themselves.

For the first time, these much-prized waters are available in your local store.

МВЖ

МИНЕРАЛЬНЫЕ ВОДЫ РОССИИ

CA REDEMPTION VALUE
MICHIGAN 10¢ Deposit
CT, DE, IA, MA, ME, NY, OR, VT 5¢ DEPOSIT

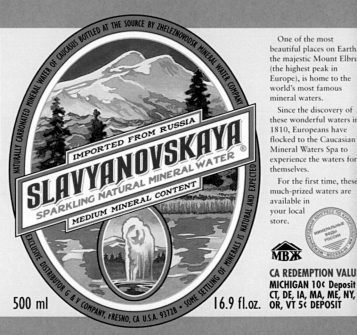

Nutrition Facts
Serv. Size 8 oz./(240 ml)
Servings: About 2
Calories 0

	% Daily value*
Total Fat 0g	0 %
Sodium 170mg	5 %
Total Carb 0g	0 %
Sugars 0g	
Protein 0g	

*Percent Daily Values are based on a 2,000 calorie diet.

NATURALLY CARBONATED MINERAL WATER OF CAUCASUS BOTTLED AT THE SOURCE BY ZHELEZNOVODSK MINERAL WATER COMPANY

IMPORTED FROM RUSSIA

SLAVYANOVSKAYA ®

SPARKLING NATURAL MINERAL WATER

MEDIUM MINERAL CONTENT

EXCLUSIVE DISTRIBUTOR G & V COMPANY, FRESNO, CA U.S.A. 93728 • SOME SETTLING OF MINERALS IS NATURAL AND EXPECTED

GOCT -13273-88

500 ml

16.9 fl.oz.

One of the most beautiful places on Earth, the majestic Mount Elbrus (the highest peak in Europe), is home to the world's most famous mineral waters.

Since the discovery of these wonderful waters in 1810, Europeans have flocked to the Caucasian Mineral Waters Spa to experience the waters for themselves.

For the first time, these much-prized waters are available in your local store.

МВЖ

МИНЕРАЛЬНЫЕ ВОДЫ РОССИИ

CA REDEMPTION VALUE
MICHIGAN 10¢ Deposit
CT, DE, IA, MA, ME, NY, OR, VT 5¢ DEPOSIT

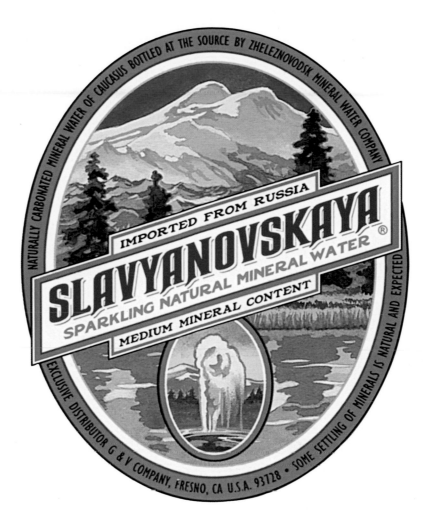

When one thinks of Russian, a snow-topped mountain-scape doesn't immediately come to mind. Nevertheless, mountains, specifically the majestic Mount Elbrus, the highest peak in Europe, are part of the country's graphic landscape. The area is well known for its mineral water and has been a popular attraction for Europeans as far back as 1810. When designing packaging for the product now that the water is available in the United States, Shields Design gave the imagery a vintage graphic treatment, reminiscent of the old travel labels that used to adorn steamship trunks, to differentiate the product and drive home its heritage.

PROJECT	RUSSIAN MINERAL WATER LABELS
DESIGN FIRM	SHIELDS DESIGN
ART DIRECTOR/	
DESIGNER	CHARLES SHIELDS
ILLUSTRATOR	DOUG HANSEN
CLIENT	G & V COMPANY

Balkans and Slavic States

This region shares its symbolism with Russia as well as much of Europe and the Near East.

Red dominates the flags in this part of the world, with Estonia as a notable exception—it's blue, black, and white.

A myriad of small countries and states including Albania, Macedonia, Bulgaria, Romania, Bosnia, Herzegovina, Croatia, Hungary, Slovakia, Czech Republic, Ukraine, Moldova, Poland, Belarus, Lithuania, Latvia, and Estonia comprise the Balkans and Slavic region of Eastern Europe. These countries were once part of a large empire, but due to wars throughout their history, they have broken up and re-assembled, only to break apart again.

⇒ Language/Gestures

The word Balkan means mountain in Turkish and is a fitting symbol for the region, where the terrain is rugged and mountainous.

The polka, a sprightly dance that became popular in the middle and late 19th century, and remains so today, originated in Bohemia.

𝘟 People

The legend of bloodsucking vampires who sleep in a coffin by day and prowl the streets at night looking to drink the blood of the living originated in the Slavic regions of Eastern Europe. It is said that the legend may have been inspired by the life of Vlad the Impaler, a ruler of Walachia, which is now part of Romania, who is thought to be responsible for having brutally killed hundreds of people in the 15th century. In fact, the legendary vampire Count Dracula called Transylvania home, a region that is southeast of the present-day Hungarian border to central Romania. The word "transylvania" means "beyond the forest."

Frédéric Chopin, Poland's greatest composer, is said to have composed music that reflects the Polish national spirit.

In 1980, Lech Walesa founded Solidarity, Poland's first independent trade union under a Communist regime, and became the party's leader. Walesa subsequently has come to represent millions of workers in Poland and was awarded the Nobel peace price in 1983.

POLA HONORA
sustavi za poboljšanje kakvoće vode

Pola Honora, dipl. ing.
direktor

10000 Zagreb, Vodnjanska 9
Tel./Fax 01 307 9524
Mob. 099 546 476
e-mail pola-honora@zg.tel.hr

While the United States and other countries use cyclic arrows to indicate recycling, designers at Likovni Studio in Croatia developed a logo for this water purification plan that symbolizes recycling with an illustration of a snake eating its tail.

PROJECT	POLA HONORA BUSINESS CARD
DESIGN FIRM	LIKOVNI STUDIO D.O.O.
ART DIRECTOR	DANKO JAKSIC, TOMISLAV MRCIC
DESIGNER	DANKO JAKSIC
TYPE DIRECTOR	MLADEN BALOG
CLIENT	POLA HONORA

POLA HONORA
sustavi za poboljšanje kakvoće vode

Pola Honora, dipl. ing.
direktor

10000 Zagreb, Vodnjanska 9
Tel./Fax 01 307 9524
Mob. 099 546 476
e-mail pola-honora@zg.tel.hr

VARAŽDINSKE TOPLICE

Varaždinske Topolice, a Croatian spa/resort in Japan, needed a logo that would translate across cultures and languages. The simple graphic devised by designers at Likovni Studio does just that. The simple illustration, rendered in a style in keeping with Japanese characters and art, depicts steam rising from the water.

PROJECT	VARAŽDINSKE TOPOLICE LOGO
DESIGN FIRM	LIKOVNI STUDIO D.O.O.
ART DIRECTOR	DANKO JAKSIC
DESIGNER	TOMISLAV MRCIC
ILLUSTRATOR	TAKAKO ADACHI
TYPE DIRECTOR	MLADEN BALOG
CLIENT	VARAŽDINSKE TOPOLICE

Africa and The Near East

The so-called cradles of civilization, the Near East and North Africa, represent humankind's historic ability to surpass tribal social order and create complex communities with established institutions such as religion, education, medicine, and law.

Early writing systems such as hieroglyphics were invented here more than three thousand years ago. They were later succeeded by cuneiform and eventually, by the phonetic script that first appeared at Byblos in Phoenicia and presumably evolved into the various modern scripts like Arabic, Greek, Latin, and Cyrillic.

The Near East is the seat of three of the world's great religions: Judaism, Islam, and Christianity. Representing human faith in a Supreme Being, each of these beliefs has established its own system of icons that remind believers of various segments of dogma and lore.

Africa

Africa, the world's second largest continent, is home to more than fifty different countries and 3000 ethnic groups, all with their own unique symbols, art, and culture.

Today, the world has discovered that this continent should be considered a symbol of humankind. The earliest remains of human life were uncovered by the Leakey family in the Olduvai Gorge in the last half of the twentieth century, debunking any lingering beliefs that the first human beings had emerged from the Mesopotamia near Israel. Anthropological studies of seemingly primitive tribes revealed rich and diverse oral histories, folklore, and forms of government. Africa's varied cultures have become symbols of the need to learn more about diverse ancient traditions in a world becoming increasingly homogenous.

The Subsaharan African native has long represented humanity's primitive origins, even though the cultures located in this and adjacent regions are complex and diverse. Societies such as the Zulu, Masai, Watusi, and Wendabi bear little resemblance to the early European perception of the ignorant savages that adventurers and fortune hunters believed inhabited the tropical forests and savannas of central and southern Africa.

People

Symbols of aboriginal innocence and wisdom, the Bushmen and Hottentots, two nomadic pygmy tribes, have made the South African desert their home as well. Despite the harshness of desert life, they believe they are part of the natural world that surrounds them and respect the rights of every living creature to take part in its bounty. The Zulus, on the other hand, are a highly sophisticated feudal society that historically worshipped the spirits of animals, the elements, and deceased warriors. Figures of power and pride, Zulu warriors remain the most vivid symbol of Subsaharan Africa even in modern times.

Animals

Unlike the associations with fertility, wealth, and death found in Asia and Egypt, the African iconography of snakes closely resembles Aztec and Norse lore. The snake represents the rain and earth. In southeastern Africa, the image of a snake falling from the sky symbolized rain, water, and sometimes lightning. A giant snake was also used to represent the earth in many ancient African paintings; its undulations signified the hills and valleys of the Great Rift zone of eastern Africa.

Symbols of ill intent and bad behavior, baboons are considered mischievous human beings punished by a god for their wrong doings. According to Bushman legend, baboons were changed

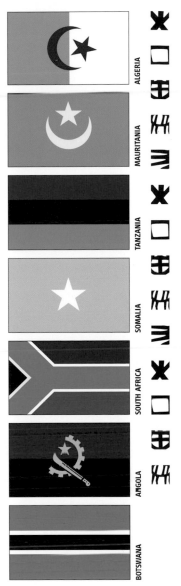

ALGERIA

MAURITANIA

TANZANIA

SOMALIA

SOUTH AFRICA

ANGOLA

BOTSWANA

Many of Africa's flags employ a familiar crescent-and-star motif as seen on the flags of Mauritania, Algeria, and Angola.

by the supreme god Cagn into barking primates that live primarily on scorpions and beetles. This deity had sent his son Cogaz into the bush to collect sticks for making bows. The baboons taunted and killed the young god, then strung up his body and danced around it. In retaliation, Cagn used his magic by driving a peg into each baboon's backside while it danced, changing it into a primate.

The Bushmen believe that the first Bushman was born from a praying mantis. When the earth was covered in water, a bee carried a mantis over the waters while searching for land. But its passenger became heavier as it became wearier. Spotting a half-open white flower, the bee laid the mantis inside the blossom and planted within it the seed of the first human being. As the sun rose, the bee died and the mantis awoke in the flower, finding the first Bushman by its side.

✤ Plants

Both the Bushmen and the Hottentots believe that water flowers such as white lotuses and water lilies are the spirits of girls who angered the rain god by not speaking quietly or reverently about it. Those who show disrespect are struck by lightning and reappear as flowers growing in the water. Because these flowers are the embodiment of their deceased daughters, the tribesmen do not pick the blossoms.

The decorative ax is a symbol of the chief or other high-ranking official in central and western African cultures. This concept is similar to the ancient European belief that a hammer was the weapon of the storm gods. According to many legends, a storm god would destroy a demon or giants by striking it with a hammer. Since the weapon was made of metal, the resulting blow would create sparks, which were associated with lightning.

A common shape in medieval European heraldry, three rings symbolized honor, fidelity, and perseverance. But among the Luba of central Africa, three rings depict the unending continuity of life—the change of seasons, the succession of day and night, and the harmonious balance found in nature. This same image signifies the Sun, the Moon, and the Creator in other tribal lore.

Knots are often used to signify a bond. For example, the three knots tied into the cord worn by Christian monks signified that the individual was bound to three vows—poverty, celibacy, and obedience. The noose of Isis—a cord tied into a knot that forms a circle—symbolized eternity in ancient Egypt. However, the Yaka tribespeople of central Africa believe that this same knot symbolizes the union of the earth and its inhabitants. This symbol is used as a talisman to protect an individual's home and land.

In a similar vein, the endless knot (*p'an-chang*) is one of the eight jewels of Buddhism and is regarded as a symbol of happiness. Found in many African motifs, the endless knot is considered a symbol of the union of all earthly creatures.

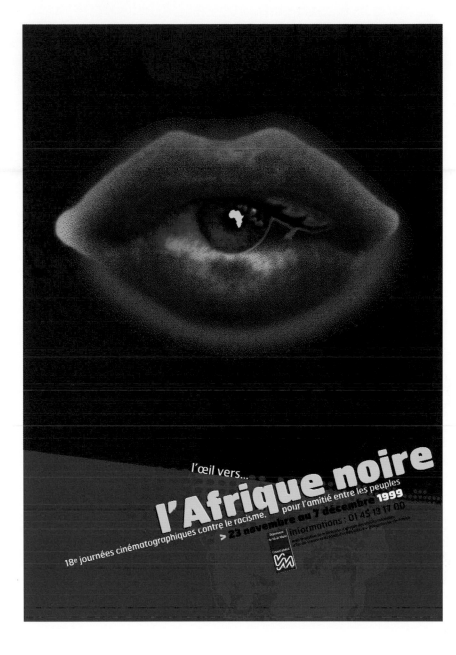

 In this poster, used in France to promote a film on Africa, designers nestled an eye with a map of Africa as its pupil between two lips. They placed the eye in a mouth to symbolize the important role that oral traditions play in Africa and its films. The combination of these three elements, which is laid atop of a detailed map of Africa, communicates much more than the oral traditions used in African cinema to represent the country's tradition of storytelling and passing down oral histories from generation to generation.

PROJECT L'OEIL VERS...L'AFRIQUE NOIRE POSTER
DESIGN FIRM MURIEL PARIS ET ALEX SINGER
CLIENT MAISON DES YEUNES ET DE LA CULTURE
 "LA LUCARNE" À CRÉTEIL

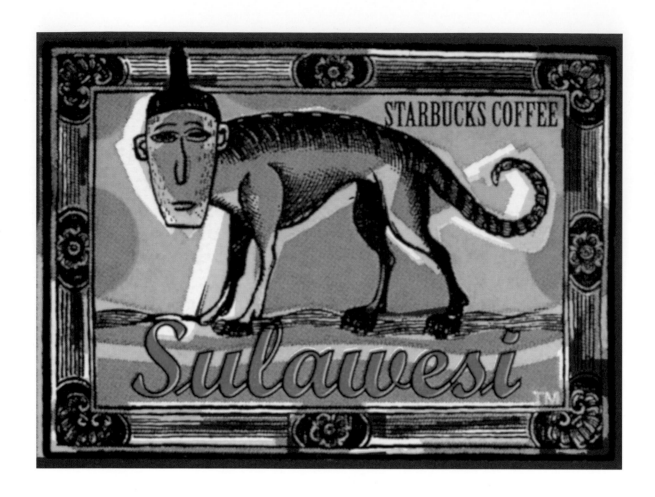

This stamp adorns Starbuck's Coffee Company's Sulawesi Blend. The illustration is a mythical hybrid creature based on three distinct African influences that characterize the coffee: a monkey to represent the diverse, distinctive, and intriguing qualities of the coffee; a cat to represent its elegant, smooth, and earthy flavor; and a human as a salute to the coffee growers of Sulawesi. "The face is a derivative of a traditional Sulawesi mask," said designer Bonnie Dain. "The green color palette was chosen to reflect the tropical atmosphere of Sulawesi. We added bits of red and blue to complement the green."

PROJECT	STARBUCK'S COFFEE COMPANY SULAWESI STAMP
DESIGN FIRM	STARBUCK'S DESIGN GROUP
ART DIRECTOR	WRIGHT MASSEY
DESIGNERS	DAVID LEMLY, BONNIE DAIN
ILLUSTRATOR	DAVID LEMLY
CLIENT	STARBUCK'S COFFEE COMPANY

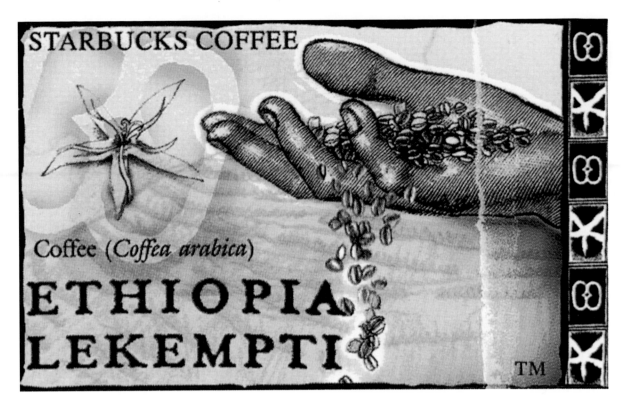

An open hand dripping coffee beans is the focal graphic in this Starbuck's stamp for the company's Ethopia Lekempti coffee. As one might guess, the hand symbolizes the human aspects of growing and cultivating coffee beans—something that is becoming increasingly rare in today's manufacturing environment where so many functions once performed by people are now automated by computer. Opposite the hand is a flower. It isn't just any flower, but an arabica coffee flower, symbolizing Starbuck's standards for freshness. Finally, the vertical border on the right of the stamp has its own significance—both practical and steeped in African heritage. According to designers, they needed an icon that would fit the stores' menu board design. The menu board icons are always one color, so the new design had to be easy to read when it was displayed. Designers decided to use an authentic African carved symbol of a bean and a silhouette of a coffee flower to enhance the design and give it a genuine look and texture.

The color palette is significant also, in that it was chosen to reflect the region, give the stamp a worldly appearance, and make the stamp look as if it was printed in the 1920s.

PROJECT	STARBUCK'S COFFEE COMPANY'S ETHIOPIA LEKEMPTI STAMP
DESIGN FIRM	STARBUCK'S DESIGN GROUP
ART DIRECTOR	MICHAEL CORY
DESIGNER/ ILLUSTRATOR	DARRYL COLLINS
CLIENT	STARBUCK'S COFFEE COMPANY

Egypt

Egypt represents an ancient civilization and knowledge since lost in the sands of time.

The Egyptian crest—the eagle of Saladin—stands at the center of the national banner, a lasting reminder of the country's great sultan, Saladin, who founded an Egyptian dynasty during the twelfth century A.D.

Egypt was once a lush, prosperous valley that edged the Nile River. Its rulers, the pharaohs, commanded tribute in the form of gold, diamonds, furs, ivory, and spices from as far away as the Ivory Coast and as near as the Sudan. Home to a complex society that embraced the concept of life in the afterworld, Egypt represents an ancient civilization and knowledge that have been lost in the sands of time.

Legends say that when the Roman conqueror Julius Caesar ordered the burning of the Great Library at Alexandria, he condemned the accumulated learning of the ancients to a fiery death and made way for the birth of modern civilization. But the physical record of this once-great civilization remains as a lasting testament—and riddle—to what used to be the hub of the ancient world.

Animals

The crocodile of the Nile River was considered by ancient Egyptians to be one of the followers of Seth, the god of misrule. Known as Sebek, this crocodile-headed god was revered as lord of the primordial chaos. Crocodiles were worshipped and mummified by Egyptian believers. Ancient Romans believed that a crocodile's hide placed over a yard gate would protect the enclosed property from damage by hailstorms.

The Aztecs and Mayans revered the crocodile as a symbol of fortune and power. The Aztec astrological sign of the crocodile—*cipatli*—promises fertility and wealth to those born under its influence. But not everyone has respected the crocodile's nature. During the Middle Ages, many Europeans regarded the crocodile as a symbol of the jaws of hell. Later, it came to represent hypocrisy, since the reptile reputedly shed tears of compassion after devouring its prey.

The seemingly undemanding bactrian camel was a symbol of moderation and sobriety in ancient times throughout the Near East and North Africa. Saint Augustine associated this beast of burden with the Christian ideal of humility, bearing the burdens of life without complaint, in many of his evangelical writings during the fifth century A.D. In areas where the camel was virtually unknown, however, its slow pace was considered a sign of laziness. And its profile symbolized arrogance and selfishness.

✶ *People*

A symbol of ancient Egypt's wealth and grandeur, the figure of the adolescent pharaoh Tutankamen is a relatively recent phenomenon. Discovered in the 1920s, the bust of King Tut, a wooden sculpture overlaid with gold and stone, became a popular icon in both Europe and North America when the novelty-hungry public first saw photographs in newspapers and magazines. His image was employed on everything from cigarette packaging to movie-palace facades, and he quickly became the best known of the pharaohs.

☐ *Shapes*

Architectural marvels of the ancient world, the Egyptian pyramids have come to symbolize preservation and durability. Built to house the remains of pharaohs waiting to enter the other world, the pyramids' usual shape has become synonymous with ancient Egypt itself, as has the great Sphinx at Giza.

The Egyptian Sphinx, which stands amid the pyramids, depicts the head of the pharaoh Chephren joined to a lion's body, symbolizing his invincibility. A number of later male and female pharaohs, including Amenemhet III, were similarly portrayed in stone reliefs and murals along the upper Nile River.

However, it is the sphinx of Greek mythology that provides the most familiar understanding of this mythological creature. A winged lion with a woman's head, the sphinx stood at the roadside, challenging travelers to solve her riddle and devouring those who failed. Symbolizing the riddle of human existence that each person is challenged to answer, the sphinx was finally defeated by the hero Oedipus.

☐ A classic symbol of rejuvenation and preservation, Smith Design Associates used a stylized pyramid to convey a profound message in this logo for Atlantis Health Systems.

PROJECT	ATLANTIS HEALTH SYSTEMS LOGO
DESIGN FIRM	SMITH DESIGN ASSOCIATES
ART DIRECTOR	MARTHA GELBER
DESIGNER	EILEEN BEREZNI
CLIENT	ATLANTIS HEALTH SYSTEMS, INC.

The Cross

The cross is one of the most prominent figures in symbolism, representing many abstract concepts in a variety of contexts. For example, in numerous central and southern African traditions, the cross signifies the crossroads between life and death.

The geometric interpretation of the cross is the intersection between the vertical points—above and below, and the horizontal points—left and right. Enclosed within a circle, this symbol signifies the division of a calendar year into four seasons. Laid flat, it was applied by Roman architects and city planners as the ideal city plan. Later, it became the traditional floor plan for cathedrals.

The first biblical references to the cross come from a description of Paradise, which had four rivers flowing through it, intersecting in the center. As the symbol of Christianity, the cross is most commonly associated with the death of Christ by crucifixion, a common form of execution in those days. Early Christians did not readily accept this emblem. The fish was an earlier symbol of Christianity—a reference to Christ as a fisher of men. The Greek word for fish, *ichthus*, was also a hidden acronym that Christians read as Iesous Christos, God and Savior. The cross, however, was a quick and simple mark that could be scratched or painted on doorways and removed or disguised during the days when Romans persecuted converts to this new Jewish sect. By the middle of the second century A.D., it had evolved into an emblem of victory over death.

St. Andrew's cross forms the shape of the letter *X*, and is so named because the apostle Andrew was said to have been crucified on one. This shape is also called the witches knife, and has been found on talismans worn to ward off evil. The thief's cross is shaped like the letter *Y* and signifies the Tree of Life.

There are many types of crosses and they have sometimes taken on complex shapes and meanings.

☐ Jesus Christ was reputedly crucified on a tau cross, which is formed like the uppercase letter *T*, although it is more commonly depicted as a lowercase t in modern times. This was an ancient Judaic symbol of divine election, referenced in the Old Testament (Ezekiel 9:4).

☐ The Egyptian cross of life—ankh—bears a circle or oval
at the top and was directly associated with the sun god,
Amon-Re, worshipped by monotheists like the pharaoh
Amenhotep IV. The Copts (Egyptian or Coptic Christians)
adopted this same cross as a symbol of eternal life gained
through the death and resurrection of Jesus Christ.

☐ The clover cross bears three-leaf clovers on each end—
a metaphor for the story of St. Patrick and the sham-
rock. The Celtic cross, which combines a cross and a cir-
cle surrounding the intersection, is symbolic of heroic
quests such as the epochal search for the Holy Grail.

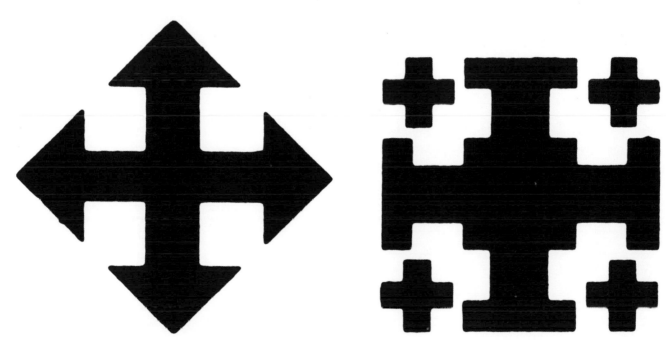

□ The *Nyilaskereszt*—the arrow cross— bears points at each of the four ends and represents the arrows of the Magyar-Hungarian conquerors.

□ Composed of a single liturgical cross and four small crosses, the Jerusalem cross was an insignia of the Kingdom of Jerusalem during the Crusades. .

Israel

The Jewish homeland harbors a mix of symbols sacred to many religions and cultures.

The Zionist Star (Star of David) has been a traditional emblem of Judaism for centuries and is a symbol for the modern-day state of Israel.

Regarded as the land of milk and honey by the prophet Moses, who led the Israelites out of their Egyptian captivity, Israel is a land with an ancient past even though it was not a recognized nation until 1948. In less than a century, this nation has established itself as a symbol of the fight for the right to practice the Jewish faith and culture. For Jews, this small strip of arid land represents freedom, after centuries of persecution and forced exile.

Ironically, this same nation is also the home of many Christian and Islamic monuments, including the birthplaces of Jesus Christ and the patriarch Abraham. Consequently, it bears many symbols considered sacred to those religions as well.

Animals

The owl has symbolized wisdom and scholarship in many cultures. It was often depicted alongside the Greek deity Athena, the goddess of wisdom. And in one medieval British cathedral, the prophet Moses was portrayed carrying a staff topped with an owl. Able to see in the dark and a patient predator, a black owl was the emblem of Mongol emperors such as Kublai Khan. Emblazoned on military shields, the symbol was adopted because the life of great Mongol conqueror, Genghis Khan, had been saved by an owl.

However, in early Christian iconography, the owl signified a turning away from Christ's spiritual light. In China, the owl is the opposite of the phoenix. It is a harbinger of misfortune that reputedly plucks out the eyes of its parents before it learns to fly. Its eerie gaze is said to be the result of this morbid event. Even the Aztecs regard the owl as a demonic night-creature and an evil omen. The Mayans depicted the god of death—Hunhau—as a creature with an owl's head. And the hooting of an owl is regarded as an omen of death by both the Hottentots and Bushmen of southern Africa. All of these visions are much more in keeping with the Judaic visions of the bird.

The owl was the dark companion of Adam's first wife, Lilith, according to Kabbalistic texts and Talmudic commentaries such as those found in Erubin 100b and Shabbath 151b. She refused to be subservient to Adam and left the Garden of Eden to live along the shores of the Red Sea. Three angels were sent to kill her, but spared her life on the condition that a hundred of her children die each day. She agreed and cursed humankind by vowing to slay the children in their sleep. The only progeny to be spared were those who wore a silver amulet bearing the names of the three angels. Lilith and the owl are also said to rule the *yenne velt*, the other side of the mirror.

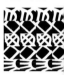

✦ Plants

A familiar evergreen found in the Mediterranean and the Near East, cedar trees were exported from Lebanon to Egypt by the pharaohs, who used this durable wood for building ships, furniture, coffins, and tools. In fact, this fragrant wood was frequently used to symbolize durability in the Old Testament. For example, in Psalm 92, it is noted that "The righteous will flourish like a palm tree, they will grow like a cedar of Lebanon." And in Psalm 29, the voice of God is compared to the cedars' reputed strength, saying "The voice of the Lord breaks the cedars."

Because cedarwood resists decay, it was used to build houses of worship, where it signified protection of the soul from moral corruption. The cedar tree's close association with King Solomon reinforces its religious significance in Judaic and Christian traditions. According to the Book of Kings in the Old Testament, Solomon built the House of the Forest of Lebanon, the Hall of Pillars, the Hall of the Throne, Hall of Judgment, and his own home out of carved cedar wood. And his crowning achievement—the great temple in Jerusalem—employed cedar for the roof beams, rafters, and interior paneling. The inner sanctuary—which housed the Ark of the Covenant—was likewise lined with ornately carved cedar overlaid with gold.

The date palms that flourish in the desert oases of the Near East and North Africa were a frequent subject in religious texts such as the Bible and the Qu'ran. A symbol of victory, palm fronds were laid before Christ's path as he entered the city of Jerusalem. The Greek and Egyptian goddesses of victory—Nike and Hathor—were often portrayed holding a palm frond. Combined with lilies and grapes, date palms signify the fruits of Paradise that all worthy beings will share following the Last Judgment.

◻ Shapes

The six-pointed star or hexagram that appears on the Israeli flag is commonly called the Star of David or the Star of Zion. But before the establishment of this modern nation, this particular star was also called Solomon's seal. According to the Kabbalistic texts, King Solomon, who was the son of David and Bathsheba, often used this symbol in conjunction with the Tetragrammaton (the letters YHWH, which spell Yahweh or God) as a means of exorcising demons and summoning angels. For freemasons, who apply this image to their individual lodge seals, the star and the four Hebrew letters together represent totality.

☥ People

Nomadic cultures exist on every continent. The indigenous tribes of the North American plains, the Mongolian herders, the Sami of Scandinavia, the camel-herding Tuareg of Mali, the Aborigines of Australia, the Bushmen of the Kalahari, and the Ludar gypsies of Rumania are just a few examples of peoples who did not structure their societies around established towns or farms. But it's the Bedouin of Saudi Arabia (southeast of Israel)—often depicted riding a camel across the scorching sand—who have come to symbolize the wandering nomad. Perceived by city dwellers as a harsh, solitary existence lived out in an unyielding desert or on the arctic tundra, the nomadic life often signifies humanity's one-on-one battle with nature or the seemingly unsettled—and thus uncivilized—nature in human beings.

☫ Animals

Although the ox is not commonly associated with the desert, this domesticated beast of burden has served as a symbol of patient service and passive strength throughout the Near East. In ancient Babylon, the ox was a sign of wealth. This began when the beasts were used as a medium of exchange. Modern western cultures, on the other hand, perceive the ox as a slow, plodding creature that suggests steady, consistent labor without cunning or guile.

The ox makes a number of appearances in the Old and New Testament. For example, in Proverbs 14:4, the ox plays an important role because of its strength: "Where there are no oxen, there is no grain; but abundant crops come by the strength of the oxen." The ox is one of the four beasts referenced in Saint John's Apocalypse. The winged ox is the symbol of the evangelist Saint Luke.

Mother and Child

Universal Symbol
COMPASSIONATE PEACE

The image of a mother holding her infant child in a nurturing embrace has served as the emblem of unconditional love, undying devotion, security, and protection worldwide. From pre-Christian sculptures unearthed in the Iraqi desert and Egyptian murals dating back to the time of Moses, to Michelangelo's Pieta, to a photograph of the pop-singer Madonna and her newborn child, few people can say they have no emotional reaction to this powerful universal archetype.

This maternal image is also closely associated with the moon and the earth. The sun is frequently associated with masculine characteristics such as power, strength, and vitality. The moon, on the other hand, represents feminine traits such as fertility, nourishment, and growth. The term Mother Earth is a direct reference to the bond between human beings and the planet they inhabit—an undeniable interdependence.

 The bond between a mother and her child is the central focus of this logo.

PROJECT **CHILD GUIDANCE CLINIC LOGO**
DESIGN FIRM **PETERSON & COMPANY**

The Asian Pacific Rim

Isolated from the western world, first by its remoteness and later by choice, the nations of the Asian Pacific Rim developed their cultures and symbologies with little western influence. The only exception were the tales told by traders traveling along the Silk Road, which was established by Alexander the Great in 325 B.C., connecting the regions between Persia and China (including the Georgian steppes, India, Nepal, and Mongolia) via the inhospitable Gobi and Taklimakan deserts.

Only the most adventurous or devout western souls ever ventured along the treacherous land or sea routes. And the Indian rajahs, Chinese emperors, and Japanese shoguns continued to limit European access to their empires' rich sources of tea, gold, and silk until the nineteenth century. This history of protected isolationism, however, doesn't mean that the Asian Pacific Rim lacks in cultural symbolism. On the contrary, these nations are some of the most complex and visually ritualized societies on the planet. Many of their written languages are ideographic rather than phonetic, using single-character words that evolved from pictographs instead of strings of individual sounds represented by letters.

Despite shared characteristics, such as the adoption of Buddhism and Vedism (Hinduism) as the main religions, there are many distinct differences among the Asian Pacific Rim cultures. The symbolic languages of southern China, India, Indonesia, and Thailand display a brilliantly hued flamboyance typical of the subtropics. Colorful images of animals, flowers, and geometric shapes such as the pa gua, the lotus blossom, and the tiger are used as metaphors for spiritual health, good fortune, and other abstract concepts. Moving northward, Japan uses more conservative, representative shapes, with less embellishment and a limited color palette. For example, the bold simplicity of the family crests, called *mon*, were usually printed in indigo blue or cherry red against a plain white backdrop on banners and kimono fabrics. And situated between Siberia and northern China, Korea developed a minimalist system of iconography, employing highly stylized, bold images of ravens, bears, whales, and other creatures.

China and Hong Kong

China's culture features an abundance of visual symbols and rich symbolic language.

The large yellow star in the national flag of China and Hong Kong represents its communist ideology. The four smaller stars depict the four social classes: peasant, working, borgeoisie, and capitalist.

China's culture first took shape over a millennium before the Emperor Huang Ti's dream, in 2650 B.C., of a civilization that could live in harmony with nature. It developed scientifically, artistically, and philosophically in relative isolation until the Italian merchant Marco Polo entered the Forbidden City to meet the Emperor Kublai Khan in the thirteenth century A.D. Seven hundred years later, China's culture contains an abundance of visual symbols. Although western symbolism has been incorporated into this rich symbolic language, it has not replaced traditional meanings or messages. In fact, the introduction of western iconography has simply expanded the Chinese visual vocabulary.

Animals

The dragon remains the most popular of the four sacred animals that govern China's destiny; the others are the unicorn (page 165), the phoenix (page 151), and the tortoise. Unlike the western view of dragons—diabolical, fire-breathing, reptilian monsters that are often destroyed by archangels, saints, and knights—these ornate creatures symbolize happiness and fertility, not only in China but in many other Asian Pacific Rim cultures as well. In fact, a dragon is a common decorative element intended to ward off evil spirits. Besides being the national symbol of China, the dragon also represents the fifth sign of the Chinese zodiac (Ming Shu). The dragon's color can make a difference; a turquoise dragon was the emblem of the emperor, symbolizing both the east, the sunrise, and the life-giving spring rains. A white dragon, however, signified the west and death. Only the emperor was allowed to wear garments decorated with yellow dragons, symbols of power.

According to legend, Chinese dragon boat racing originated in the fourth century B.C., in the wake of a tragedy. Chinese poet and statesman Ch'u Yuan, exiled from his village for giving advice that would have saved it from destruction, determined to end his life by throwing himself into the Mi Lo river. Local fisherman raced to the river to try to save him. They desperately searched for his body, beating drums furiously to prevent him from being eaten by fish or water dragons. For centuries, these long narrow boats, with a dozen paddlers and a drummer beating out the pace, were raced every summer solstice in a symbolic search for Ch'u Yuan.

Another spiritual animal, the unicorn (k'i-lin), was originally depicted by artists as a dragon-horse. It symbolizes purity and a type of physical strength ruled by a virtuous mind.

The phoenix (feng-huang), on the other hand, is said to typify the entire world, unlike the phoenix of Egypt (benu), which symbolizes immortality and resurrection. According to the Chinese, the phoenix's head symbolizes heaven, its eyes are the sun, its back stands for the crescent moon, its wings are the wind, its feet symbolize the earth, and its tail represents the plants. In imperial China, the phoenix also symbolized the empress and conjugal union.

The last of the spiritual animals, the tortoise (kwei), which is said to live for a thousand years, symbolizes longevity in both China and Japan. According to legend, a tortoise rose from the Lo River before the Emperor YŸ, bearing nine prime numbers in the form of a magic square on his back. When added horizontally or vertically, each set of three numbers totaled fifteen. From this revelation, the emperor wrote the Lo Shu, which detailed his nine-fold plan for governing China.

Symbolizing a good marriage, Mandarin ducks (y'an yang) always live in monogamous pairs in the wild. Mandarin duck figurines and printed bed linens are popular wedding gifts in many parts of China.

 People

Buddha is seen throughout Asia in homes, temples, and public buildings. However, there is not one single, acceptable image of this figure. There are hundreds of postures, facial expressions, and even body shapes used to portray the many personality facets and reincarnations of Buddhism's most revered person.

Plants

Because pear trees can grow to be very old, the distinctively shaped pears (li, known as Asian or Asiatic pears in the West) that they bear are symbolic of longevity in China. However, pear blossoms are symbols of mourning and the shortness of life. A long-held superstition forbids friends or lovers from slicing pears and sharing the pieces. This should come as no surprise, since the Chinese word for pear also means "to forsake or depart."

In China, oranges symbolize good health, love, and happiness. They are often placed on dishes before ancestral shrines as offerings, along with fresh cakes and other treats.

The lotus flower is commonly associated with Asia even though it also grows in abundance in the Mediterranean. Egyptian myths about the birth of the world's creator depicted him rising from the center of a white lotus blossom that had grown from the primordial chaos. The blue lotus was the emblem of the god Nefertum, who presided over the ancient city of Memphis. Similar stories developed in India, where the creator, Lord Brahma, was born from a lotus blossom that grew from the navel of Lord Vishnu, who was asleep in the water. A symbol of purity, knowledge, and self-creation, many Vedic deities are pictured holding or sitting on a white or pink lotus blossom.

TABOO

A familiar American adage states that an apple a day keeps the doctor away. But in China, the word for apple—*p'ing*—is very similar to the word for disease—*ping*. Consequently, it's considered inappropriate to depict an individual giving an apple to someone who is ill, or as a sign of good health. Oranges, however, are very appropriate.

MISCOMMUNICATIONS

When the Coca-Cola Company first marketed its famous product in China, it used characters that closely approximated its westernized name. But ke-kou ke-la means "bite the wax tadpole" or "a scholarly mouth stops the traveler" in various Chinese dialects. So the Coca-Cola marketing team researched a second time through the 40,000 characters of the Chinese language to find a refined phonetic equivalent, ko-kou ko-le, which means "happiness in the mouth."

TABOO

Rice is an important staple in the Asian diet and is treated with great reverence. Grains of this sometimes-precious commodity were placed in the mouth of the deceased so that he or she would not starve in the afterworld. For many decades there was a taboo that forbade the discarding of leftover rice. It was believed that the thunder god would strike any wasteful person. There is also only one occasion in which rice can be filled above the rim of the bowl. That's when it is offered as a sacrifice to one's ancestors.

The lotus blossom is one of the eight jewels of Buddhism, which include the white lotus (purity), the white parasol (protection from evil desire), two fishes (rescue from the ocean of earthly misery), the conch shell (the blessings of following the right path of behavior), the standard or banner (the victory of Buddhism), the endless knot (the continuing cycle of reincarnation), the vase (the treasury of spiritual wealth), and the yak-tail fly swatter (manifestations of the Tantra). The white lotus is regarded as the symbol of the female immortal Ho-hsien-ku, who is frequently depicted carrying a magic lotus blossom. She is one of the Eight Immortals who live on the Islands of the Blessed, or Paradise. In Taoist art, these deified entities are frequently depicted greeting the god of longevity—Shou-hsing—as he arrives on the island flying on a white crane. The Chinese consider the blue or night lotus (*ch'ing*) to be an emblem of spiritual and physical cleanliness. Tibetan Buddhists regard this particular blossom as the symbol of Green Tara, the deified Chinese princess who married King Srang-Tsan Gampo and introduced Buddhism to Tibet. Nepalese Buddhists, on the other hand, regard this flower as the symbol of Manjushree, the god of wisdom.

☐ *Shapes*

The yin and yang symbol represents the eternal balance of life: hot and cold; day and night; masculine and feminine; positive and negative; life and death. Yin is depicted as the dark hemisphere of the circle; yang is the light hemisphere.

In a similar vein, the eight trigrams that compose the *pa gua* symbolize how positive (unbroken line) and negative (broken line) energy flow in harmony with each other. These same trigrams also combine into the sixty-four hexgrams in the popular form of divination known as the I Ching.

The multi-tiered pagoda symbolizes Asia itself and is the architectural embodiment of Asian religion, signifying the absolute and nirvana (spiritual enlightenment). Buddhists believed that each person achieves truth by progressing through a series of incarnations or lifetimes, gleaning wisdom from experience. Each tier of a pagoda represents a higher level of existence and experience, suggesting the rise of the human spirit to its ultimate goal.

≡Ɔ *Language/Gestures*

A hand gesture seen in many images of Buddha, the abhaya mudra is a symbol of protection; the palm of the hand is turned outward and all five fingers are extended upward. Charity is designated by turning the palm outward, but extending the fingers downward (*varada*). An argument is indicated by forming a circle with the thumb and index finger while extending the remaining three fingers upward and facing the palm outward; this gesture is called the vitarka mudra.

THE PEARL OF THE ORIENT

In Chinese decorative arts, two dragons are often depicted fighting over a pearl, or a dragon is shown playing with a pearl over a river. This common image combines the symbols for rain (the dragon) and thunder (the pearl)—powerful natural elements that brought life to the rivers and the rice fields. Many myths and tales also depict dragons guarding or fighting for pearls. In even earlier times, thunder was believed to be the father and oysters to be the mothers of pearls, which grew in the moonlight that shimmered over the water. In China, this precious stone represents chastity.

In much the same way, the pearl signifies virginity in many Islamic and European nations. However, in Christian iconography, the pearl's rarity and enclosure in an oyster shell made it an ideal symbol for the teachings of Christ inaccessible to non-believers and precious to its adherents.

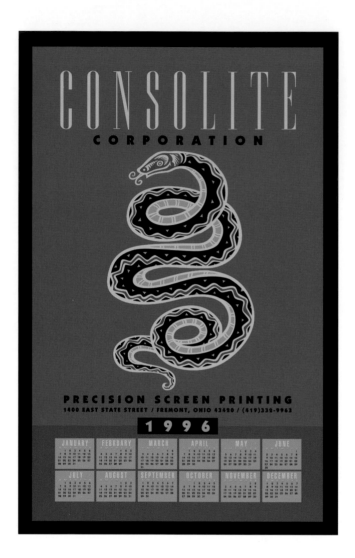

 A metaphor for the earth and rain in many cultures, the snake as depicted in this calendar is a symbol for the Chinese year of the snake, 1996. Tracy Sabin employed a highly stylized version of this reptile who the Chinese believe represents birth and renewal.

PROJECT	CONSOLITE CALENDAR
DESIGN FIRM	TRACY SABIN GRAPHIC DESIGN
ART DIRECTOR	BOB STETZEL
DESIGNER/ILLUSTRATOR	TRACY SABIN
CLIENT	CONSOLITE CORPORATION

The Phoenix

Universal Symbol
THE FLIGHT OF THE FIREBIRD

Legends of the phoenix, which was viewed as a symbol of the Sun in ancient Egypt, have spread from the Mediterranean, the Near East, and North Africa across Asia to China and Siberia. The Egyptians believed that the phoenix (benu) was one of the first creatures to arise from the primordial chaos. Shaped like a heron, it flew to India where it spent the first five hundred years of its life in seclusion. Then it flew to the Egyptian temple of the Sun god at Heliopolis laden with rare spices. It settled on the altar, set fire to itself, and burned to ashes. On the third day a young phoenix arose from its remains and flew away—not to be seen for another five hundred years.

Associated with immortality and rejuvenation, the phoenix rising from a pyre was portrayed by the Romans on imperial coins and mosaics as the vitality of their expanding empire. Early Christians applied the phoenix as a symbol of Christ's resurrection. Jewish legend tells how the phoenix (milcham) refused to eat the fruit of the Tree of Knowledge that had led to Adam and Eve's fall from grace. As its reward, God spared the phoenix from mortality, allowing it to live undisturbed in a walled city for a thousand years. At the end of that time, the bird's nest burns, consuming the bird and leaving an egg. From that egg, another phoenix arises, living for another thousand years.

In China, the phoenix is the second of the four sacred animals that rule the nation's destiny. Its appearance portends the arrival of wise and beneficent rulers. And the five colors of its plumage represent five cardinal virtues. A symbol of conjugal union, the phoenix (feng-huang) was also the emblem of the Chinese empress.

But in Russia and Siberia, the phoenix or firebird is the hero of a romantic legend and a symbol of goodness. While hunting in the forest, a prince finds the brilliantly plumed firebird as it plucks a piece of golden fruit from a silver tree. The prince captures the bird, but sets it free after listening to its pleas. In return, the firebird gives the prince a magic feather. The next morning, the prince encounters a group of princesses enchanted by an evil sorcerer and held captive in a nearby castle. He falls in love with one of the beauties and vows to free all of them from their captor's spell, despite their warnings that all trespassers have been turned to stone. Protected by the magic feather, the prince gains entry to the castle and thwarts the sorcerer's spells. The firebird itself appears, casting its own spell among the sorcerer's demon guards. As it dances wildly around the room, it points out an egg that contains the sorcerer's soul. The prince crushes the egg, immediately killing the sorcerer and freeing the princesses.

A classic Chinese symbol for the phoenix used to portend the arrival of wise and beneficent rulers, the phoenix used on the packaging for a brand of Moon cakes also conveys its Chinese origins.

PROJECT	MOON CAKE PACKAGING
DESIGN FIRM	KAN & LAU DESIGN CONSULTANTS

 A metaphor for purity and knowledge throughout Asia, the lotus blossom is also a symbol for Asia itself. This classic image is the primary focus in a promotion for a new note issuance by the Macau New Bank, which conducts most of its business along the Asian Pacific Rim.

PROJECT MACAU NEW BANK NOTE ISSUANCE
 PROMOTION POSTER
DESIGN FIRM KAN & LAU DESIGN CONSULTANTS
ART DIRECTORS KAN TAI-KEUNG, FREEMAN LAU SIU HONG
DESIGNERS KAN TAI-KEUNG, FREEMAN LAU SIU HONG,
 VERONICA CHEUNG LAI SHEUNG
COMPUTER
ILLUSTRATOR BENSON KWUN TIN YAU
CLIENT BANK OF CHINA, MACAU BRANCH

Chopsticks can be a strong symbol of Asia if presented properly. Here, this common eating utensil was used as the primary graphic in a promotion for Design in China 2001. Designers transformed the calligraphic Chinese character—"~"—into a color bar with modern san serif type. When combined with the chopsticks, visually depicting the numeral two, they represent the 21st century.

PROJECT	DESIGN IN CHINA 2001 PROMOTION
DESIGN FIRM	KAN & LAU DESIGN CONSULTANTS
AT DIRECTOR	KAN TAI-KEUNG
DESIGNERS	KAN TAI-KEUNG, EDDY YU CHI KONG
COMPUTER	
ILLUSTRATOR	BENSON KWUN TIN YAU
CLIENT	THE CENTRE FOR INTERNATIONAL ARTS EDUCATION EXCHANGE OF THE CENTRAL INSTITUTE OF FINE ARTS

KAN TAI-KEUNG

28/F 230 WANCHAI RD
HONG KONG
TEL 2574 8399
FAX (852) 2572 0199

靳埭強

香港灣仔道二百三十號二十八樓

 Watercolors, a watercolor brush, and Chinese characters are symbolic of Eastern culture. Here, they point to designer/illustrator Kan Tai-Keung's style and artistry and are the focal point of his business card.

PROJECT	KAN TAI-KEUNG BUSINESS CARD
DESIGN FIRM	KAN & LAU DESIGN CONSULTANTS
ART DIRECTOR/	
DESIGNER	KAN TAI-KEUNG
CLIENT	KAN TAI-KEUNG

The Chinese lunar calendar is comprised of twelve symbols of different animals, each with their own distinct meaning. These symbols correlate to the Chinese astrological signs. Someone born in the Year of the Ox, which is depicted on this New Year's greeting card in a variety of incarnations, is perceived to be trustworthy and dependable with a sense of integrity. They can also be introverted and self-confident; and can be calm, tireless workers. Like oxen, they can also be stubborn

PROJECT LUNAR NEW YEAR CARD, YEAR OF THE OX
DESIGN FIRM KAN & LAU DESIGN CONSULTANTS
ART DIRECTORS KAN TAI-KEUNG, FREEMAN LAU SIU HONG, CHAN SO HING
DESIGNERS KAN TAI-KEUNG, FREEMAN LAU SIU HONG, EDDY YU CHI KONG, CHAU SO HING, BENSON KWAN TAI YAU, VERONICA CHEUNG LAI SHEUNG, FANNY NG WAI HAN, LEUNG WAI YIN, JOSEPH LEUNG CHUNG WAI, LAN WAI HUNG, STEPHEN LAU YU CHEONG
CLIENT KAN & LAU DESIGN CONSULTANTS

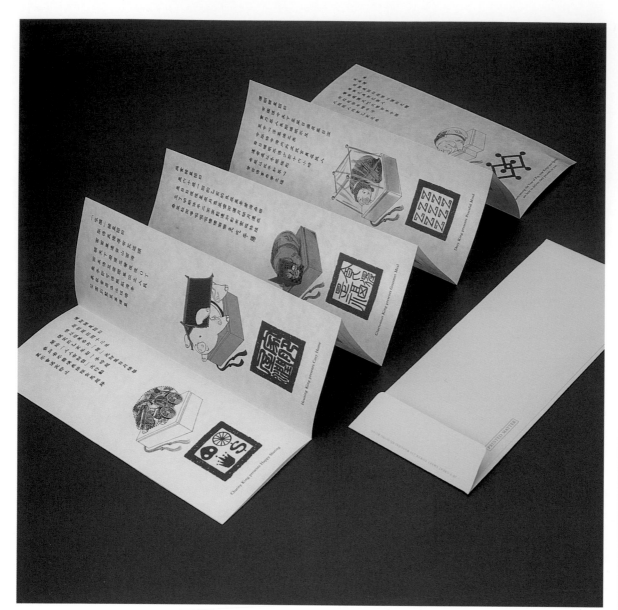

Proliferous Queen presents Creative Brain

Housing King presents Cozy Home

Gluttonous King presents Gourmet Meal

Based upon the cyclical nature of the phases of the moon, each year in the Chinese calendar is symbolized by a characteristic animal trait. The year and hour of your birth determine one's dominant animal sign, which is said to be indicative of their personality and characteristics. People born under the sign of the pig or boar are thought to be honest, simple, loyal, tolerant, and patient. They are also known to be selfless and calm, while possessing great stamina and endurance. On the negative side, they can be gullible and tactless at times.

PROJECT	LUNAR NEW YEAR CARD, YEAR OF THE PIG
DESIGN FIRM	KAN & LAU DESIGN CONSULTANTS
ART DIRECTORS	KAN TAI-KEUNG, FREEMAN LAU SIU HONG, EDDY YU CHI KONG
DESIGNERS	KAN TAI-KEUNG, FREEMAN LAU SIU HONG, EDDY YU CHI KONG, CLEMENT YICK TAT WA, BENSON KWUN TIN YAU, JOYCE HO NGAI SING, JANNY LEE YIN WA, VERONICA CHEUNG LAI SHEUNG, JAMES LEUNG WAI MO
CLIENT	KAN & LAU DESIGN CONSULTANTS

Designer Mike Quon wanted to highlight his Chinese heritage in a holiday card that communicated without words. He succeeds in this greeting that features the traditional Chinese yin-yang symbol. He makes small modifications to the symbol over the course of seven illustrations, so that by the eighth variation, Quon has turned the traditional Eastern symbol into Santa Claus, a symbol of Western culture.

PROJECT	YIN-YANG SANTA POSTCARD
DESIGN FIRM	DESIGNATION INC.
ART DIRECTOR/	
DESIGNER/	
ILLUSTRATOR	MIKE QUON
CLIENT	DESIGNATION INC.

 To convey the message that insurance provides peace of mind, designers used a traditional Chinese scale to measure the intrinsic value of insurance. Scrolls of insurance are weighed on the scale, balanced by a piece of jadeite engraved with the Chinese characters meaning peace of mind. "In ancient China, the jadeite was a precious ornament with an inscription that represents the wish dearest to the owner's heart," said Nick Tsui, art director.

PROJECT	THE HONG KONG FEDERATION OF INSURERS ANNUAL REPORT
DESIGN FIRM	CLIC LTD.
ART DIRECTOR	NICK TSUI
DESIGNER	AMMESA CHAN
CLIENT	HONG KONG DEFERATION OF INSURERS

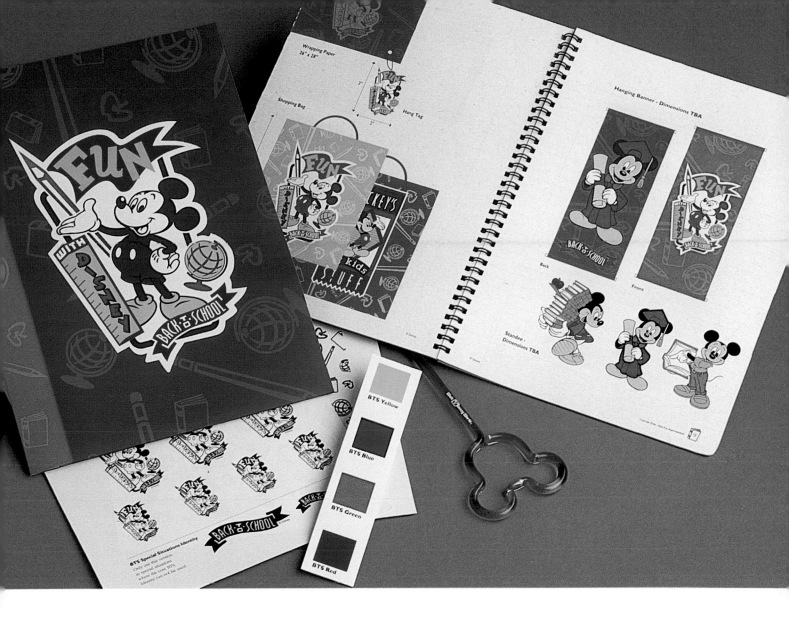

Disney's Mickey Mouse and pals are familiar symbols
throughout the U.S., but this media kit was targeted to
kids and parents doing back-to-school shopping in
Asia. The advent of the Euro Disney in Paris, coupled
with the global dissemination of Disney films, televi-
sion programs, and retail products, has made these
familiar characters global pop culture icons, not limited
to celebrity in the U.S. alone.

PROJECT	THE WALT DISNEY COMPANY BACK TO SCHOOL MEDIA KIT
DESIGN FIRM	SAYLES GRAPHIC DESIGN
ART DIRECTOR/ DESIGNER/ ILLUSTRATOR	JOHN SAYLES
CLIENT	THE WALT DISNEY COMPANY

Global Graphics: Symbols

Melissa Harris

Oriental Medicine Consultants

801 Encino Place NE

Suite B-3

Albuquerque NM 87102

505.243.5848

505.243.5865 fax

877.700.5848

根深枝繁 實碩神健

abundance

grace

great strength

harmony

nourishing

recovery

synergy

☐ Maggie Macnab combined Eastern and Western symbols in one identifying graphic for Oriental Medicine Consultants with universal recognition. Because the client is trained and certified in both Eastern and Western medicines, Macnab wanted a logo that bridged the gap for those comfortable with traditional medicine, yet interested in alternative health-care. Both worlds meet in the resulting identity that blends the Eastern I Ching and the Western medical caduceus, while the winding curves dissolve into Chi or energy. "Oriental medicine is all about energetics and balance, so incorporating all of these concepts into one symbol in a simple way was appropriate," said Macnab. "We also used support graphics in the printing with actual I Ching symbols and their slogan in Chinese calligraphy—a very ideological and visual word form."

Combining two cultures posed spatial challenges in fitting everything—copy and graphics—onto a business card. "I really like to convey information in a way that teaches something, and so we made use of the backside of the card to name the I Ching symbols and create a relationship between the symbols and the reader," added Macnab.

PROJECT ORIENTAL MEDICINE CONSULTANTS IDENTITY
DESIGN FIRM MACNAB DESIGN VISUAL COMMUNICATION
ILLUSTRATOR MAGGIE MACNAB
CLIENT ORIENTAL MEDICINE CONSULTANTS

SINGAPORE MANAGEMENT UNIVERSITY

Bonsey Design Partnership strived to communicate Singapore Management University's operations, philosophy, and future vision in this highly stylized logo featuring a lion and a shield in the form of an ancient Chinese Tangram puzzle. The lion represents the nation of Singapore, known as Lion City, and the pride it takes in its endeavors. Rather than representing an animal that is feared, the lion is perceived to be a guardian, as well as a father figure who provides guidance and wisdom. The shield has its heraldic overtones and implies stability and longevity.

These two icons are coupled in an abstract formation known as a Chinese Tangram, that "allows the lion to break free from a more predictable presentation," said Jonathan Bonsey. "The Tangram puzzle traditionally involves the distribution of seven geometric shapes to create representations of people, plants, and animals. It is a simple game but it includes almost infinite creative possibilities. It is an ancient game and yet its appeal transcends race and creed, and is as relevant today as it was thousands of years ago."

PROJECT	SINGAPORE MANAGEMENT UNIVERSITY LOGO
DESIGN FIRM	BONSEY DESIGN PARTNERSHIP
ART DIRECTOR	JONATHAN BONSEY
DESIGNER/	
ILLUSTRATOR	SIMON WONG
CLIENT	SINGAPORE MANAGEMENT UNIVERSITY

Japan

Japanese symbolism is minimalist in form, shaped by centuries of religious influence.

The red circle on the Japanese flag (which is named Hi-no-maura, meaning sun disc), depicts the rising sun—a traditional metaphor for this island nation.

Shaped in part by thousands of years of religious influence from Zen Buddhism and Shintoism, traditional Japanese symbolism is minimalist in form. Many of the beautifully classical symbols—ocean waves, flowers, birds, butterflies, and fish—are derived from nature as well as from early man-made shapes like the wheel. Family crests (mon) used during medieval times by warlords and their samurai continued this visual tradition, creating geometric symbols that are still used by well-heeled Japanese families on clothing and other personal items. In sharp contrast, modern commercial symbols frequently have more in common with popular Japanese cartoon characters, such as Sailor Moon and Hello Kitty, than with lotus blossoms and flying cranes.

An open umbrella or parasol signifies protection in many cultures, including many Buddhist cultures. The Victorian explorer Sir Richard Burton noted that in India the umbrella was a symbol of the royal family. Another adventurer, Sir John Bowring, reported that an umbrella bearing seven stars was the emblem of the King of Siam. However, there are many superstitions surrounding this symbol as well. For example, many Europeans and Americans consider an umbrella opened indoors to be a harbinger of misfortune. In Japan, open, upturned umbrellas are a symbolic remembrance of the bombing of Hiroshima during World War II. On the anniversary of this event, as a memorial to the victims, thousands of upturned umbrellas are floated on the river that flows through the city.

Animals

In Japan, the butterfly is a symbol of feminine youthfulness, in the same way it signifies both beauty and metamorphosis in the West. Two butterflies dancing around each other represent marital bliss. In Chinese culture, however, a butterfly resting on a flower symbolizes a young man in love.

Besides being a staple in the Japanese diet, certain fish have symbolic significance. The carp (koi), for example, represents courage, strength, and endurance. On Boy's Day (May 5), each family that has a son places a banner shaped like a carp in front of the house. If the family is blessed with more than one male child, a silk carp is add to the banner display for each boy.

Plants

The distinctive, many-jointed bamboo plant symbolizes eternal youth and invincible strength. Its empty heart is said to stand for modesty. Frequently, pieces of bamboo are placed in a fire; the resulting loud burst is said to drive off evil spirits. In China, branches of this plant are an emblem of Kuan-Yin, goddess of mercy.

A symbol of the emperor in Japan and of the autumn season in China, the chrysanthemum carries many meanings. It is often employed as an emblem of reflective contemplation. Combined with other elements, the chrysanthemum can also imply congratulations or a wish for long life.

☗ *People*

Around 1000 A.D., the jovial image of Mi-lo fo (Fat Buddha) spread from China throughout the Asian Pacific Rim. As a later incarnation of Buddha, this image became known in Japan as Hotei, one of the seven gods of happiness who brings merriment, peace, and prosperity to the world. Depicted holding a bag of presents and surrounded by playful children in Chinese decorative arts, in Japanese designs he is more commonly portrayed seated, holding prayer beads.

☐ *Shapes*

Used since the early days of the shogunate, mon (family crests) are simple geometric shapes that were printed onto the fabric of formal kimonos, house banners, and other possessions. Introduced into the west during the nineteenth century, the mon inspired German and Austrian designers of the Bauhaus and Wiener Werkstatte schools to create geometric trademarks, dropping the old tradition of signature and picture-based logos. Today, mon are designed for the modern-day version of Japanese extended families: major corporations.

Japan's imperial insignia (*shinki sanshu*) consists of three elements—a pearl, a sword, and a mirror—which together are kept as royal treasures in the Shinto shrine of Ise. A symbol of reflection and the soul, the mirror (*yatano-kagami*) was used by the Sun goddess Amaterasu and is presented to the nation's emperor during his coronation ceremony. Considered to be a direct descendant of the gods, he is also handed the symbol of indomitable power and truth: a sword (*ame no murakomo no tsuguri*) that was drawn from the tail of a snake by the storm god Susano-o. And finally, the emperor is presented with symbols of virtue and perception: a set of pearls, which are said to be the creation of the god Tama No-oya.

☐ The designer used the Hiro family crest or mon—an
indication of a respected clan in ancient Japan—in this
elegant logo treatment for a Japanese realtor, working
in New York.

PROJECT	HIRO REAL ESTATE CO. IDENTITY SYSTEM
DESIGN FIRM	E. CHRISTOPHER KLUMB ASSOCIATES, INC.
ART DIRECTOR/	
DESIGNER	CHRISTOPHER KLUMB
CLIENT	HIRO REAL ESTATE CO.

The Unicorn

Universal Symbol
A HORSE OF A DIFFERENT SORT

Pictured as a bearded horse with cloven hooves and a spiral horn, the unicorn is paired with the lion on Great Britain's coat-of-arms. As to its origins, many historians point to the writings of Ctesias, the Greek historian who documented tales told by soldiers and explorers who followed Alexander the Great into India. Many of them told him of a wild animal with a single horn that had remarkable healing powers. (Today, it is assumed that the men had inadequately described an Indian rhinoceros, or a goat with the rare deformity of a single, central horn.)

The tale grew to imply that the unicorn's horn could improve male potency. Consequently, it became a symbol of sexuality. During medieval times the unicorn's significance changed radically, as Christianity altered European perceptions of just about everything. The unicorn became a symbol of purity, strength, and the Virgin Mary. Fairy tales suggested that a unicorn could be caught only with the aid of a virgin. The hunted animal would seek refuge in her lap and could then be relieved of its valuable horn. Fortunate apothecaries during the Renaissance displayed their prized unicorn horn, which was ground up and added to antidotes for various poisons. The horns were frequently imported from Iceland and Greenland, where fishermen would remove them from captured narwhals—an arctic whale that grows a single spiral horn on its head.

In China, the unicorn is called Ki'lin and is revered as the first of the four sacred animals that preside over the nation's destiny. It is believed to live for a thousand years. The goddess of compassion, Kuan-Yin, is often pictured riding a unicorn. In Japan, the mythical creature is called Kirin, a symbol of purity, mental strength, and virtue, and is a symbol of purity and is the name of this old and well-respected Japanese brewery. Employing a classic depiction of the Kirin and Japanese hand-lettering, Mike Salisbury created this label for the company's mild lager.

PROJECT **KIRIN MILD LAGER PACKAGING**
DESIGN FIRM **MIKE SALISBURY COMMUNICATIONS INC.**
ART DIRECTOR **MIKE SALISBURY**
DESIGNERS **MIKE SALISBURY, TERRY LAMB**
ILLUSTRATOR **PAM HAMILTON (LETTERING)**

The logo that appears on these pocket calendars represents a mix of cultural influences. The logo is created by a Croatian design firm and is based on European mythology. The client, Seiyodo, is a retailer of European antiquities in Japan. Designers pulled these influences together in this colorful logo that depicts Europe, symbolized by the figure riding away on the back of a bull. Together, this imagery symbolizes the transfer of culture between East and West.

PROJECT SEIYODO LOGO
DESIGN FIRM LIKOVNI STUDIO D.O.O.
ART DIRECTOR DANKO JAKSIC
DESIGNER TOMISLAV MRCIC
TYPE DIRECTOR MLADEN BALOG

Starbucks' in-house design team created this logo for a new Starbucks store opening in Tokyo. They wanted a logo that would speak to Japanese culture and tradition, while still appearing "Starbuckian." To achieve both goals, designers employed an illustration of a cat with a raised paw, a Japanese symbol for good fortune and prosperity. By placing the cat in a coffee cup, designers have visually associated the feel good atmosphere of Starbucks with a cup of coffee. The painted lettering and the red and black color palette also pay tribute to Japanese culture

PROJECT	STARBUCKS COFFEE COMPANY TOKYO ICON
DESIGN FIRM	STARBUCKS DESIGN GROUP
ART DIRECTOR	MICHAEL CORY
DESIGNER/ILLUSTRATOR	BONNIE DAIN

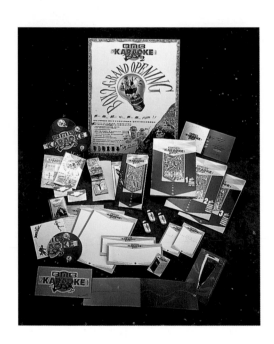

A bright idea is conveyed by the use of a light bulb in this promotional campaign designed by an American firm for the Japanese company, BMB Karaoke. The image also employs another strong metaphor. The rooster is said to ward off the demons of the night by announcing the sunrise.

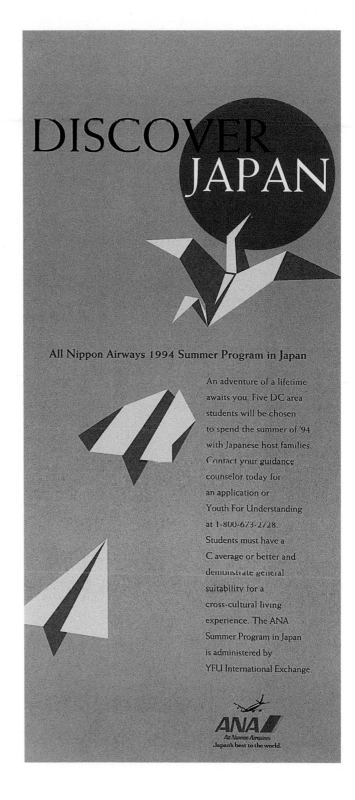

The rising sun, symbol of the Japanese imperial family and the national emblem, is effectively used in this Supon Design Group poster for an international student exchange program. Set on a gradient background, the image is also reminiscent of traditional decorative Japanese screen painting.

PROJECT **DISCOVER JAPAN POSTER**
DESIGN FIRM **SUPON DESIGN GROUP**

India

Indian images often symbolize eastern wisdom, gods, and belief in reincarnation.

The spinning wheel in the Indian national flag is a traditional symbol known as dharma cakra, which has twenty-four spokes that represent the hours of the day. This same symbol is also a metaphorical reminder of the nation's founder, Mohandas K. Gandhi, who spun his own cloth as an act of civil disobedience.

The Indo-Aryan people first settled in the Indus and Ganges River valleys around 1500 B.C., taking over lands and cities previously established by the Harrapan civilization. According to legend, the events that led to the takeover and eventual assimilation of these two unique cultures were documented in the hero-epic the Mahabharata by the elephant-headed god Ganesha and dictated by the sage Vyasa. Originally a collection of oral stories that recorded the civil war that occurred near the city now known as Delhi, the tales quickly took on religious significance. And in less than two centuries, many of the events became the basis for Vedic—or Hindu—dogma. (The Indo-Aryans are also credited with the scriptures known as the Vedas, the four books that form the basis of all Vedic rituals.)

Indian images are often employed as symbols of eastern wisdom and belief in reincarnation. Devotion to the Lords Brahma and Shiva as well as the multitude of other animal and human gods is highly visible in both rural and urban India. In fact, the nation's top-rated television series is the epic tale of Lord Shiva's life.

Animals

A familiar Indian icon is the elephant. In pre-Vedic India, myths were told about the elephant who bore the world on its back. Many centuries later, the strength of this animal was replaced by its intellect. Attributed with great intelligence, the Vedic god of writing and wisdom, Ganesha, is depicted with an elephant's head and only one tusk. According to legend, Ganesha broke his other tusk to use as a writing implement when he took dictation of the Mahabharata from the sage Vyasa. As one of Lord Shiva's sons, Ganesha is said to bring salvation from obstacles and success to the human beings who worship him.

A similar legend has grown around the elephant in other parts of the Asian Pacific Rim. In Chinese lore, the elephant is a symbol of strength as well as intelligence, and is still considered a symbol of happiness.

For centuries, the Indochinese of southeast Asia have believed that the highest form of compliment is to call a person a white elephant. In some cultures it was viewed as a creature in an advanced stage on the journey to Nirvana. An element in the Siamese coat-of-arms until 1910, the white elephant was considered a gift of great honor and esteem among the royal families of both Siam (Thailand) and Burma (Myanmar). In fact, even in modern times, only the kings of those nations are allowed to own and breed these rare pachyderms.

By tradition, only the king of Myanmar and his white elephants are allowed to touch the royal white umbrella. And when captured in the wild, a white elephant's journey from the jungle to the palace is always attended with full pomp and ceremony, as is any subsequent public appearance.

Legend has it that the gift of a white elephant by the Siamese or Myanmar king, however, often carried a double-sided meaning when not exchanged between equals. For example, the king might give a nobleman a white elephant, knowing that the lord could not afford its upkeep and thereby instigating his financial ruin. After European and American traders learned of this practice, the term "white elephant" became synonymous with an attractive present that was also a waste of money. However, there is no acknowledgment of this in Asia; the gift of a white elephant is such a high honor that any resulting loss of wealth or misfortune would be almost unthinkable.

People

India's most famous human icon is Mohandas K. Gandhi, who inspired the nation to demand independence from British rule through nonviolent means. Known as the Mahatma—a respectful title meaning little father—Gandhi was a small man who dressed in homespun cloth he made himself with a spinning wheel and a loom. Even after his assassination, Gandhi epitomized the Indian spirit, embodying the pursuit of personal enlightenment through the release of all material desires.

Shapes

The spinning wheel is an icon of Indian independence. When Gandhi began his nonviolent protest of British intervention in India, he asked all native Indians to boycott the purchase of imported wool garments made in England and to take up the ancient practice of spinning and weaving homespun cloth from shafts of grain. Until his assassination, Gandhi was frequently photographed sitting at his spinning wheel. Needless to say, this imagery confounded his British adversaries.

Considered a feminine activity in Europe, the spinning wheel is commonly associated with fairy tales such as Sleeping Beauty, who pricked her finger on a witch's spinning wheel and was left spellbound. And although the spinning wheel was an emblem of the contemplative life in medieval times, later depictions of the Fates that showed them spinning, gathering, and cutting the threads of human destiny drew subtle visual parallels to spiders spinning silk and weaving webs.

The Southwestern Pacific Rim

Australia and the surrounding islands of New Zealand, New Guinea, and Tasmania were sources of outlandish tales of man-eating clams and plants, giant crocodiles, and cannibals—tales told mostly by Chinese, Indian, and Malaysian sailors who hoped to keep ambitious Portuguese traders from swooping down on the "Great South Land." Europeans had learned of *Terra Australis Nondum Cognita* (The South Land Unknown to Us) from the writings of ancient Greek geographers, who hypothesized that there had to be a southern hemisphere since they knew there was a northern one.

A symbol for untold riches during the fifteenth century, Australia and the surrounding islands were finally opened to the European hunger for gold and spices by the Portuguese and Dutch in the 1500s and 1600s. But Australia, Tasmania, and New Zealand soon became icons of both refuge and desperation in the 1780s, when the British converted the islands into penal colonies, where political prisoners were sent to labor in the mines and royalists could find refuge from the revolutionaries in the United States.

Today, these island nations are associated with freedom, outdoor sports, and environmental diversity.

Australia

Folklore of the Aborigine and imagery of the outback are distinct to Australia.

Proud of its British heritage, Australia's flag depicts the United Kingdom's Union Jack and the constellation—the Southern Cross—that shines over the island continent.

Settled by nomadic tribes from central Asia who followed the colorful band of southern lights known as Aurora Australis, Australia is still considered an inhospitable desert filled with strange creatures. The Aborigines learned to make peace with this land when they first arrived thousands of years ago. They believe that human beings, animals, and spirits are all related in the "Dreamtime"—a period when supernatural beings created all living plants and creatures, including human beings. During the Dreamtime, the Aborigines were cousins with the kangaroos, emus, crows, eagles, hawks, and other indigenous animals. The supernatural beings created ceremonial dances that the Aborigines continue to perform with clapsticks and the low moans of the didgeridoo, telling the stories of their ancestors.

Symbols of courage in the face of incredible environmental odds, Aborigines created a symbolic language made up of geometric shapes —concentric circles, rhomboids, diamonds, and squares— that identify individuals as members of specific clans. This complex iconography is divulged only to tribal initiates, who are sworn to secrecy. It is also an integral part of the festive costumes worn for social events known as corroborees. These singing, dancing, and storytelling feasts usually take place at night before huge bonfires or by moonlight, commemorating encounters between two or more tribes—momentous events in this vast land.

Even the nineteenth-century diggers or white settlers found affinity with this desolate world, extracting gold ore, opals, copper, and other riches from the dry soil and "going native." Although much of the aboriginal life has given way to urban hardships, the idea of the outback lives on as a symbol of the nation.

Animals
The slow-moving koala (meaning "no drink") is the unofficial national animal of Australia, a symbol of both the nation and its national airline, Qantas. Endangered by hunters and forest fires, these marsupials are now protected in sanctuaries where they are provided with their favorite food leaves from a few varieties of eucalyptus tree.

The Scallop Shell

Universal Symbol
THE PILGRIMAGE OF THE SPIRIT

A common item found on the beaches of the Caribbean, scallop shells evoke the idea of war sands and gentle surf under sunny skies. The scallop shell has also been an emblem of pilgrimage—a long-distance journey intended to lead to enlightenment and blessings when completed. This simple mollusk is closely associated with Saint James the Major, patron saint of Spain, in Christian iconography. According to Christian legend, the apostle James the Major left the Holy Land after Christ's Ascension, traveling to Spain and preaching the word of God. He frequently returned to this far-off land until his death in Judea. His body was taken to Spain many years later and laid to rest in the town of Compostella. Pilgrims who came to visit his tomb wore scallop shells in their hats as a symbol of their journey (this, incidentally, assured them of a warm welcome in any Christian village they passed through on their pilgrimage). Later, Christians who had fought in the crusades, or whose ancestors had, also adorned themselves with scallop shells as a symbol of their service. More recently, when Winston Churchill was knighted, his coat-of-arms contained six scallop shells.

For Australian children, the kangaroo is most notably represented by a lovable television character named Skippy, whose national fame is comparable to that of Lassie the collie and Flipper the dolphin in the United States. One southeastern Aboriginal clan claims the kangaroo as its totem; its members believe they are descended from this large marsupial, and identify with its famed prowess as a fighter and with its ability to cover long distances in the scorching heat. Out of respect for their forebears, this particular clan does not hunt kangaroos, and considers the eating of kangaroo meat to be an act of spiritual cannibalism. (However, members of other clans may freely capture and eat these creatures without remorse and without giving offense.)

In a similar manner, the large, flightless emu is another familiar clan totem that is highly regarded by southeastern Aborigines. The feathers of this large bird were made into skirts that were worn by young unmarried women as a symbol of their purity.

☐ *Shapes*
The diamond is a symbol of the Aborigine kangaroo clan. It is a geometric motif commonly used by clan members to decorate carved ceremonial clubs and shields as well as their own bodies, which they paint during initiation rites, ancestral celebrations, and corroborees.

The unique shape of the Sydney Opera House has become a symbol for modern day Australia.

A symbol of Australia's vast and barren outback, Ayer's Rock, also signifies nature's grandeur and majesty.

 Kalina Design manufactures cooking stovetops and home appliances. Because the kitchen is often referred to as the heart of a home, the company's name, *Kalina*, which is aboriginal for love, is significant to Australian homeowners and specifically, consumers. The name is rendered in a freehand typeface that is soft and feminine to appeal to the company's target market: women. The *i* in Kalina is dotted with an open circle to represent the universal symbol for degree, a subliminal reference to cooking temperatures.

"The accompanying icon, created to resemble a hot plate, was designed with an eye to indigenous aboriginal artwork, in keeping with the company's name. "The freestyle dots and circles are intended to indicate heat radiation, and serve the purpose of providing interest by leading the eye around the logo, giving it a dynamic quality," explained Rachel Saliba, art director/designer. "They also tend to draw attention to the warm colors of the center circle, reinforcing the concept of being surrounded by warmth."

PROJECT	KALINA DESIGN LOGO
DESIGN FIRM	ADSTRACT ART PTY LTD.
ART DIRECTOR/	
DESIGNER	RACHEL SALIBA
CLIENT	KALINA DESIGN

 Simplistic and earthy graphics depicting traditional
Australian symbols create the visual theme on the print-
ed collateral for Walkabout, a seminar for business lead-
ers. The kangaroo and snake, indigenous to Australia,
are widely recognized symbols, while the others are
lesser known. These graphics take their cue from
Australian Aboriginal motifs without copying them
directly.

PROJECT WALKABOUT SEMINAR GRAPHICS
DESIGN FIRM CATO PARTNERS
DESIGNER CATO PARTNERS
CLIENT INTERNATIONAL YOUNG PRESIDENT'S
 ORGANIZATION

WALKABOUT

176

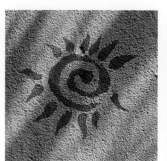

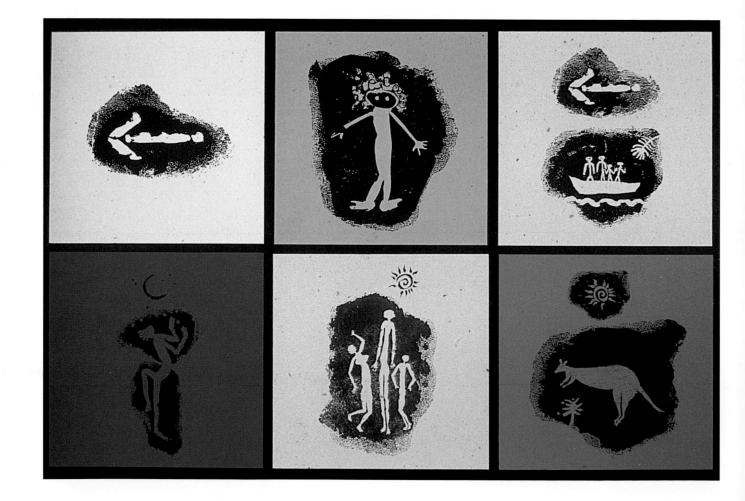

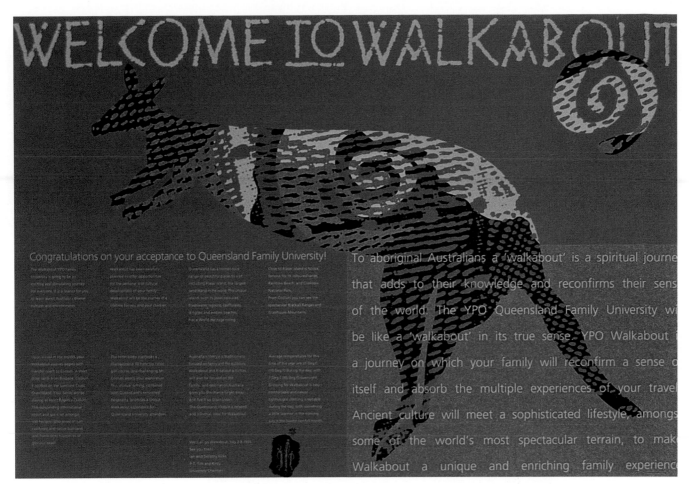

WELCOME TO WALKABOUT

Congratulations on your acceptance to Queensland Family University!

To aboriginal Australians a 'walkabout' is a spiritual journey that adds to their knowledge and reconfirms their sense of the world. The YPO Queensland Family University will be like a 'walkabout' in its true sense. YPO Walkabout is a journey on which your family will reconfirm a sense of itself and absorb the multiple experiences of your travel. Ancient culture will meet a sophisticated lifestyle amongst some of the world's most spectacular terrain, to make Walkabout a unique and enriching family experience.

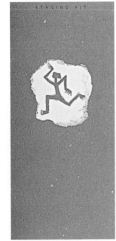

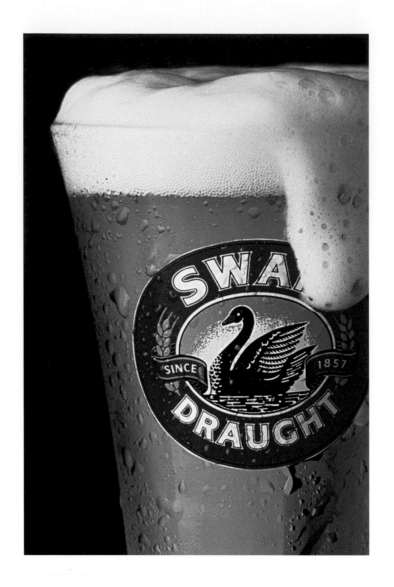

The Swan Brewing Company adopted the black swan as their corporate branding, shown in its logo designed by Cato Partners. The black swan is found only in Australia, specifically in Perth, the brewery's home city.

PROJECT	**THE SWAN BREWING COMPANY IDENTITY**
DESIGN FIRM	**CATO PARTNERS**
DESIGNER	**CATO PARTNERS**
CLIENT	**THE SWAN BREWING COMPANY**

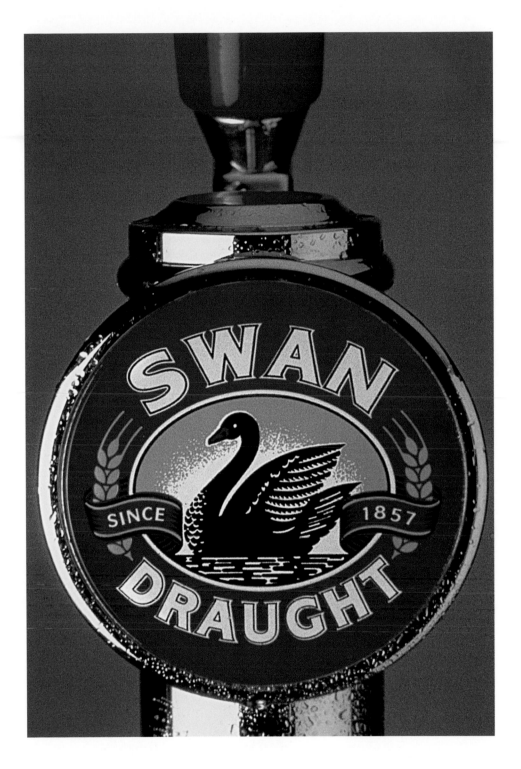

The Bird of Paradise is the national emblem of New Guinea, which is a major coffee grower in the South Pacific. As such, the symbol not only makes for a dynamic packaging identity, but reinforces the product's name— New Guinea Gold—and its origins as well.

PROJECT	NEW GUINEA GOLD COFFEE PACKAGING
DESIGN FIRM	CATO PARTNERS
DESIGNER	CATO PARTNERS
CLIENT	ROBERT TIMMS

The Tiger

Universal Symbol

TYGER! TYGER! BURNING BRIGHT

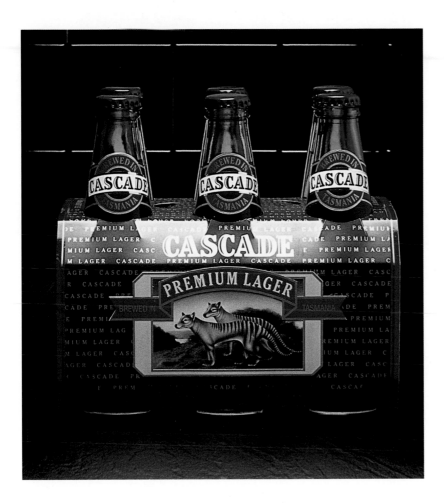

A symbol of both wonder and fear, stories about the tiger were originally brought home to Greece by Alexander the Great's soldiers after they returned from India around 350 B.C. But Indian folklore about the tiger did not always emphasize the animal's fierceness. Some myths described a tigress luring human men into the water by changing into a beautiful human siren and then devouring them, an act of cunning as well as ferocity. And the tigress's maternal instincts were often exploited by hunters, who placed a mirror on the ground in hope that the tigress would look into it and believe her reflection was a cub wanting to be nursed. Although it is India's national animal, the tiger has lately acquired a less respectable emblematic use as the symbol of the Tamil Tiger militants on the island of Sri Lanka, south of India.

Regarded as a being to be respected, Sumatrans make tigers annual indoor offerings of flowers and rice, and outdoor offerings of meat and water buffalo blood. If the pawprints of a tiger are discovered around a village, it's a sign that someone has committed some wrongdoing. The suspect must then be caught and fined livestock or rice. The village chief must then bring meat to the forest to make amends with the tiger.

The Chinese portray the tiger as a symbol of wealth and power. It is often depicted alongside the dragon as companion to the god of wealth. The tiger is also one of the Chinese astrological signs, and the patron of gamblers. It is often depicted holding money in its forepaws, a common image in Asian gambling casinos. In northern China and Siberia, the tiger's image is frequently affixed to the front of a house or a grave marker to ward off specters and evil visitations.

The Tasmanian Tiger, an extinct animal once found only in Tasmania, the island state of Australia, has become synonymous with the region. Used here, the tiger distinguishes Cascade Brewery's packaging from its competition.

PROJECT **CASCADE PREMIUM LAGER PACKAGING**
DESIGN FIRM **CATO PARTNERS**
DESIGNER **CATO PARTNERS**
CLIENT **CASCADE BREWERY**

New Zealand

Elaborate Maori tattoos and the kiwi bird are two diverse symbols of New Zealand.

Using the same elements found in Australia's national banner (the Union Jack and the Southern Cross constellation), New Zealand's flag employs only the four major stars in the constellation in its design.

Descended from Polynesians, New Zealand's Maoris trace their genealogy back to the passengers of specific canoes that sailed from Tahiti and Raratonga during the Great Migration of 1350 A.D. Building elaborately carved wooden shelters, these tropical people adapted to the North Island's lush rainforests, discovering new sources of food and introducing others such as yams (*kumara*). Unlike their Aboriginal neighbors in Australia, Tasmania, and New Guinea, the Maoris developed a system of geometric symbols used to communicate abstract concepts. They applied—and continue to apply—these decorative shapes to buildings and costumes as well as to their own bodies.

The elaborate designs that Maori warriors tattooed on their bodies were symbolic of the individual's relative ability to withstand pain, and were intended to terrify any enemy. Coupled with the famous haka chants—insulting songs accompanied by foot stamping, obscene facial gestures, and body slapping—the Maori started every battle with this show of prowess and pride, and ended each fight at sunset. Despite this feisty past, New Zealand is regarded as one of the most peace-loving nations on earth (and one of the first to declare itself a nuclear-free zone). As a nation, it stands for peaceful coexistence and conscious conservation of natural resources.

Animals

The kiwi, a small, flightless bird that inhabits New Zealand's South Island, serves as a national symbol. It is also the emblem of the New Zealand branch of the ill-fated ANZAC (the volunteer Australian and New Zealand Army Corps), which suffered heavy casualties during World War I, especially at the battle of Gallipoli. The bird was a central device on their coat-of-arms, and its name is still used as a nickname for the military, as well as for New Zealand's citizens in general.

Plants

The ponga or silver fern tree is indigenous to the nation's north and south islands. A Maori symbol of championship or achievement, it is New Zealand's national emblem. It is the main element on the Breast Star awarded to Knights and Dames receiving the New Zealand Order of Merit.

Shapes

Numerous geometric shapes, used by the Maori, signify various abstract concepts. For example, the *poutama*, which means steps, symbolizes the steps an individual takes to gain knowledge. It is embroidered on the official academic dress of the chancellors at New Zealand's University of Otago. The *koru-fern* signifies people, vitality, and growth. This symbol is associated with chivalry, and is incorporated into the New Zealand Collar of the Order of Merit. The *maunga* (mountain) symbolizes heritage and protection. Since it is the offspring of the *papatuanuku*, Mother Earth, it is sometimes associated with the concepts of healing, creativity, and humility.

Sheep and Lambs

Universal Symbol
WHILE SHEPHERDS WATCHED OVER THEIR FLOCK

New Zealand's most successful export—the sheep—has long been a symbol of harmlessness and helplessness in the face of danger. It is the feminine opposite to the aggressive, masculine determination depicted by the ram. The sheep's offspring—the lamb—is more than simply a universal sign of youthful frailty and innocence.

In ancient Near East civilizations, a lamb was frequently sacrificed to the Supreme Being. And in many Christian and European cultures, the lamb symbolizes the ultimate triumph over evil because it is also equated with the sacrifice made by Jesus Christ on behalf of humanity. However, the Byzantine Orthodox Church forbade the use of the lamb as a symbol of Christ because it was also associated with pagan rituals.

Conveying a sense of comfort through the application of a familiar New Zealand and Australian animal, a sheep is used as the central focus of the logo for Outback Blues, a line of pillows that are faux fleece on one side and denim on the other.

PROJECT OUTBACK BLUES COUCH CUSHION PACKAGING
DESIGN FIRM COMMUNIQUÉ MARKETING
DESIGNER/
ILLUSTRATOR ANNE R. POWELL
CLIENT CARPENTER CO.

Resources

United Nations
The United Nations Educational, Scientific, and Cultural Organization (UNESCO) maintains a lending library of about 150,000 volumes of publications printed by UNESCO and other international organizations concerned with education, science, culture, communication, social sciences, and human sciences.

UNESCO Library
7 Place de Fontenoy
75352 Paris 07 SP FRANCE
Phone (33) 1 45 68 19 57
Fax (33) 1 45 68 56 17

Consulate Offices
To obtain up-to-date information about the culture, customs, tourism, and protocol for a particular nation, contact that country's local mission. Consulate offices are located in major cities around the world where diplomatic relations have been established such as New York, Chicago, San Francisco, Toronto, Vancouver, London, Paris, Hong Kong, and Tokyo. The following is a list of missions established in New York:

Consulate General of Argentina
12 W. 56th St.
New York, NY 10019
212/603-0400

Australian Consulate General
630 Fifth Ave., Suite 420.
New York, NY 10111
212/408-8400

Austrian Consulate General
31 E. 69th St.
New York, NY 10021
212/737-6400

Consulate of The Bahamas
231 E. 42nd St.
New York, NY 10017
212/421-6420

Consulate General of Belgium
1330 Avenue of Americas
New York, NY 10019
212/586-5110

Consulate General of Brazil
630 Fifth Ave., Suite 2720
New York, NY 10111
212/757-3080

British Consulate General
845 Third Ave.
New York, NY 10022
212/745-0200

Consulate General Du Canada
1251 Ave. of the Americas
New York, NY 10020
212/596-1600

Consulate General of Chili
866 UN Plaza, #302
New York, NY 10017
212/980-3366

Consulate General of Colombia
10 E. 46th St.
New York, NY 10017
212/949-9898

Consulate General of Costa Rica
80 Wall St.
New York, NY 10005
212/425-2620

Cyprus Consulate General of the Republic
13 E. 40th St.
New York, NY 10016
212/686-6016

Consulate General of Denmark
885 Second Ave., 18th Fl.
New York, NY 10017
212/223-4545

Consulate General of France
934 Fifth Ave.
New York, NY 10021
212/606-3600

Consulate General of Germany
460 Park Ave.
New York, NY 10022-1971
212/308-8700

Greek Consulate General
69 E. 79th St.
New York, NY 10021
212/988-5500

Consulate General of India
3 E. 64th St.
New York, NY 10021
212/774-0600

Consulate General of Indonesia
5 E. 68th St.
New York, NY 10021
212/879-0600

Consulate General of Ireland
345 Park Ave., 17th Fl.
New York, NY 10154
212/319-2555

Consulate General of Israel
800 Second Ave.
New York, NY 10017
212/499-5300

Consulate of Italy
690 Park Ave.
New York, NY 10021
212/737-9100

Jamaica Consulate General
767 Third Ave.
New York, NY 10017
212/935-9000

Consulate General of Japan
299 Park Ave, 18th Fl.
New York, NY 10171
212/371-8222

Kenya Consulate
424 Madison Ave.
New York, NY 10017
212/486-1300

Consulate General of South Korea
460 Park Ave. South.
New York, NY 10016
(at 57th St)
212/752-1700

Consulate General of Malaysia
313 E. 43rd St.
New York, NY 10017
212/490-2722

Consulate General of Mexico
8 E. 41st St.
New York, NY 10017
212/689-0456

Consulate General of Monaco
845 Third Ave.
New York, NY 10022
212/286-3330

Consulate General of Morocco
10 E. 40th St.
New York, NY 10016
212/758-2625

Consulate General of Nepal
820 Second Ave.
New York, NY 10017
212/370-4188

Consulate General of The Netherlands
1 Rockefeller Plaza, 11th Fl.
New York, NY 10020
212/246-1429

Consulate General of Norway
825 Third Ave.
New York, NY 10022
212/421-7333

Consulate General of Pakistan
12 E. 65th St.
New York, NY10021
212/879-5800

Consulate General of
The People's Republic of China
520 12th Ave.
New York, NY 10036
212/330-7400

Consulate General of Poland
233 Madison Ave.
New York, NY 10016
212/889-8360

Consulate General of Portugal
630 Fifth Ave.
New York, NY 10111
212/246-4580

Russian Consulate General
9 E. 93th St.
New York, NY 10128
212/348-0926

Singapore Mission to the UN
231 E. 51st St.
New York, NY 10022
212/826-0840

Consulate General of Spain
150 E. 58th St.
New York, NY 10155
212/355-4080

Consulate General of Sweden
885 Second Ave, 45th Fl.
New York, NY 10017
212/583-2550

Consulate General of Switzerland
665 Fifth Ave., 8th Fl.
New York, NY 10022
212/758-2560

Thai Consulate General
351 E. 52nd St.
New York, NY 10022
212/754-1770

Consulate General of Turkey
821 UN Plaza, 5th Fl.
New York, NY 10017
212/949-0160

Books & Publications
Bayley, Harold. *The Lost Language of Symbolism:
An Inquiry into the Origin of Certain Letters,
Words, Names, Fairy-Tales, Folklore, and
Mythologies*. London, UK Ernest Benn, Ltd. 1990.

Beane, Wendell C. and William G. Doty. *Myths,
Rites, Symbols: A Mircea Eliade Reader*. New
York, NY Harper Torchbooks, 1975.

Biedermann, Hans, and trans. James Hubert.
*Dictionary of Symbolism Cultural Icons and the
Meanings Behind Them*. New York, NY
Meridian Books, 1994.

Goldsmith, Elisabeth. *Ancient Pagan Symbols*.
Detroit, MI Gale Research Co., 1976.

Harrington, Lyn. *Australia & New Zealand Pacific
Community*. Camden, NJ Thomas Nelson Inc.,
1969.

Jung, Carl G. *Man and His Symbols*. Garden City,
NY Doubleday & Company, Inc., 1964.

Levi-Strauss, Claude. *Totemism*. Boston, MA
Beacon Press, 1962.

Massola, Aldo. *The Aborigines of South-Eastern
Australia As They Were*. Melbourne, Australia
William Heinemann Australia Pty. Ltd., 1971.

Steiner, Henry and Ken Haas. *Cross-Cultural
Design Communicating in the Global Marketplace*.
London, UK Thames and Hudson, 1995.

Whittick, Arnold. *Symbols Signs and Their
Meaning and Uses in Design*. Second edition.
Newton, MA Charles T. Branford Company, 1971.

Directory of Contributors

Addison Branding and Communications
50 Osgood Place Suite 400
San Francisco CA 94133
www.addison.com

Adstract Art Pty Ltd.
593-595 Bridge Road, Richmond
Victoria
Australia 3121
Rachel@adstract.com.au

Ana Couto Design
Rua Joana Angélica 173, 3º andar/Ipanema
22420-030 Rio de Janeiro
Brazil
acgd@anacouto-design.com.br

Animus Communicaçáo
Ladiera Do Ascurra 115-A
Rio de Janiero/RJ/22241-320
Brazil

Anti-Matéria Design
Rua Itu, 234 / 92
CEP 13 25-340
Campinas, SP
Brazil
Gmachado_design@hotmail.com

Becker Design
225 East St. Paul Avenue
Suite 300
Milwaukee, WI 53202
beckerdsng@aol.com

Bonsey Design Partnership
179 River Valley Road
Level 5, Unit 1 R.V. Building
Singapore 179033
jonathan@bonsey.com.sg

Braue Design
8 Eiswerkestrasse
27572 Bremerhaven
Germany
info@brauedesign.de

CMA
1207 Dunlavy
Houston, TX 77019
cmadesign.com

Carmichael Lynch
800 Hennepin
Minneapolis, MN 55403

Carter Wong & Partners
29 Brook Mews North
London W2 3BW
United Kingdom

Cato Partners
254 Swan Street
Richmond 3121
Victoria, Australia
chairman@cato.com.au

CommuniQué Marketing
1520 West Main Street
Richmond, VA 23220-4687

Clic Ltd.
Kornhill Metro Tower
1 Kornhill Road, Suite 801
Quarry Bay
Hong Kong
clic@clic.com.hk

The Design Company
One Baltimore Place, Suite 170
Atlanta, GA 30308

Design Factory
3 & 4 Merrion Place
Co. Dublin
Ireland

Designation Inc.
53 Spring Street, 5th Floor
New York, NY 10012
mikequon@aol.com

Duck Soup Graphics
257 Grand Meadow Crescent
Edmonton, Alberta T7L 1W9
Canada

E. Christopher Klumb Associates, Inc.
260 Noroton
Darien, CT 06820

El Caracol, Arte y Diseño
Avenida Camelinas No. 333
Fracc. Rancho del Charro
58070, Morelia, Michoacan
Mexico

Erwin Zinger Graphic Design
Bunnemaheerd 68
9737 RE Groningen
The Netherlands
Erwin_zinger@hotmail.com

HGV Design Consultants
45A Rosebery Avenue
London EC1R 4RP
England
design@hgv.co.uk

Fabrice Praeger
54 Bis Rue de l'Ermitage
75020 Paris
France
Telephone (+39) 01 40 33 17 00

Factor Design Ag
Schultublatt 58
20357 Hamburg
Germany
www.factordesign.com

and

461 Second Street, Suite 202
San Francisco, CA 94107

Gillis + Smiler
737 North Alfred #2
Los Angeles, CA 90069
chergillis@aol.com

Greco Design Studio
Via Reggio Emilia 50
00198 Rome
Italy
Greco_design@flashnet.it

Greenfield/Belser Ltd.
1818 N. Street NW, Suite 225
Washington DC 20036
mhitchens@gbltd.com

Greteman Group
1425 E. Douglas
Wichita, KS 67214
sgreteman@gretemangroup.com

Hornall Anderson Design Works, Inc.
1008 Western Avenue, Suite 600
Seattle, WA 98104
C_arbini@hadw.com

Incognito Design Oy
Töölönkatu 11
Fin-00100
Helsinki
Finland
info@incognito.fi

Interbrand Avalos & Bourse
La Pampa 1351
Capital Federal
Argentina
cavalos@avalosbourse.com.ar

João Machado Design, Lda.
Rua Padre Xavier coutinho
n° 125-4150-751 Porto
Portugal
www.joaomachado.com

Kan & Lau Design Consultants
28/F Great Smart Tower
230 Wanchai Road
Hong Kong

Lambert Design
7007 Twin Hills Avenue, Suite 213
Dallas, TX 75231

Likovni Studio D.O.O.
Dekanici 42, Kerestinec
10431 SV. Nedjelja
Croatia
tmrcic@list.hr

Macnab Design Visual Communication
12028 N. Highway 14, Suite B
Cedar Crest, NM 87008
mmacnab@macnabdesign.com

Malik Design
88 Merritt Avenue
Sayerville, NJ 08879

Meryl Pollen
2525 Michigan Avenue, G3
Santa Monica, CA 90404
mpollen@att.net

McCullough Creative Group
890 Iowa Street
Dubuque, IA 52001
mcg@dubuque.net

Mike Salisbury Communications
2200 Amapola Court
Torrance, CA 90501

Mires Design, Inc.
2345 Kettner Blvd.
San Diego, CA 92101
dara@miresdesign.com

Miriello Grafico, Inc.
419 West G Street
San Diego, CA 92101
chris@miriellografico.com

Muriel Paris et Alex Singer
20 rue Dautancourt
75017 Paris
France
parism@worldnet.fr

Peterson & Company
2200 N. Lamar Street, Suite 310
Dallas, TX 75202

RevoLUZion
Uhlandstrasse 4
78579 Neuhausen ob Eck
Germany
info@revoLUZion.com

Rigsby Design
2309 University Boulevard
Houston, TX 77005
lrigsby@rigsbydesign.com

R2 Design
Praceta D. Nuno Álares Pereira
20 5° FQ-4450-218 Matosinhos
Portugal
R2design@mail.telepac.pt

Sabingrafik, Inc.
7333 Seafarer Place
Carlsbad, CA 92009
tracy@sabin.com

Sayles Graphic Design
3701 Beaver Avenue
Des Moines, IA 50310
sayles@saylesdesign.com

Smith Design Associates
205 Thomas Street
P.O. Box 190
Glen Ridge, NJ 07028
assoc@smithdesign.com

Starbucks Coffee Company
Starbucks Design Group
2401 Utah Avenue South
Seattle, WA 98134
1-800-Starbuc

Studio GT & P
Via Ariosto, 5 05034 Foligno (PG)
Italy
Gt&p@cline.it

Supon Design Group
1700 K Street NW, #400
Washington, DC 20006
Suponp@supon.com

Susan Meshberg Graphic Design
44 West 75th Street, #2A
New York, NY 10023

Swieter Design United States
3227 McKinney Avenue
Suite 201
Dallas, TX 75204
Michele@swieter.com

Tieken Design and Creative Services
2800 N. Central Avenue, Suite 150
Phoenix, AZ 85004

Toni Schowalter Design
1133 Broadway, Suite 1610
New York, NY 10010
tonidesign@aol.com

Vaughn/Wedeen
407 Rio Grande NW
Albuquerque, NM 87107

Walsh & Associates, Inc.
4464 Fremont N.
Suite 310
Seattle, WA 98103

The Weiser Design Communicates
167 Hillrise Drive
Penfield, NY 14526
pweiser@eznet.net

The Weller Institute for the Cure of Design
P.O. Box 518
Oakley, UT 84055

Yfactor, Inc.
2020 Clark Boulevard, Suite 1B
Brampton, ON L6T 5R4
Canada
Anthony@yfactor.com

The Authors

Anistatia R Miller and **Jared M. Brown** write and design from their home in Boise, Idaho. Together, they were contributing editors for Adobe's on-line magazine and have written articles on modern iconography for *Icon Thoughtstyle, Wine Spectator, U&Lc,* and *Adobe Magazine.* They have also published numerous books including *Shaken Not Stirred: A Celebration of the Martini* and *On This Day in History.*

Cheryl Dangel Cullen is a writer and public relations consultant specializing in the graphic arts industry. She is the author of *Graphic Design Resource Photography, The Best of Annual Report Design,* and *The Best of Direct Response Graphics.* Cullen writes from her home near Ann Arbor, Michigan, where she plans and implements public relations programs for clients in the graphic arts, paper, and printing industries. She frequently gives presentations and seminars on innovative ways to push the creative edge in design using a variety of substrates.